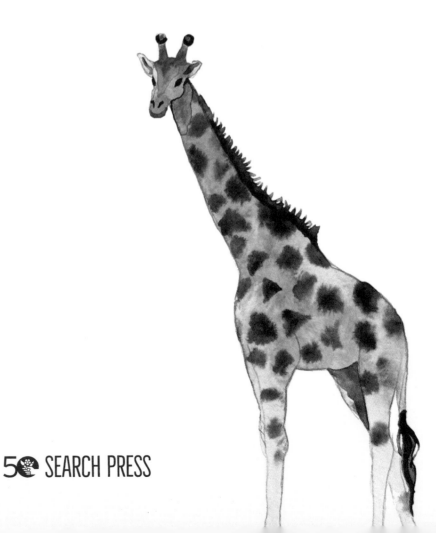

PAINT 50 WATERCOLOUR ANIMALS

From basic shapes to amazing paintings in super-easy steps

Marina Bakasova

50 SEARCH PRESS

CONTENTS

Seal	40		Pig	76		
Goat	42		Wolf	78		
Koi Carp	44		Skunk	80		
Sloth	46		Swan	82		
Meerkat	48		Rabbit	84		
Beaver	50		Flamingo	86		
Crab	52		Fox	88		
Seagull	54		Rhinoceros	90		
Stork	56		Crocodile	92		
Lion	58		Pufferfish	94		
Tiger	60		Peacock	96		
Zebra	62		Lemur	98		
Hamster	64		Bluebird	100		
Squirrel	66		Butterfly	102		
Toucan	68		Owl	104		
Gopher	70		Ram	106		
Elephant	72		Mouse	108		
Monkey	74		Ostrich	110		

Introduction

This book introduces you to painting animals in watercolour through a collection of 50 fun and colourful creations. I have included a range of animals to inspire everyone, from a lazy panda to a colourful peacock.

Each project begins with a line drawing that you can either copy or trace, and a list of the colours that have been used to create the final painting. Once you have drawn the animal, I have used stage-by-stage techniques to guide you through how to apply those first washes of paint, how to create patterns, and how to add the details and finishing touches that will make your creations come to life. To get the best results, I recommend reading through the whole project before you start so that you know where you might have to work quickly or so that you can prepare your colours in advance.

Watercolours are my favourite medium with which to paint and I am always looking at ways that I can improve and develop my painting and illustration skills. The sequence and 'formula' of these projects are based on my own experience and mistakes. I want to share my top tips with the world so that everyone can enjoy working with this exciting medium and create their own menagerie of watercolour animals. All the animals in this book can be created using only a handful of basic techniques and very few tools and materials, all of which I will outline in the next few pages.

I hope that this guide will be helpful not only to the professional artist but also to those who want to learn watercolour but do not know where to start. It is my aspiration that this book will unite people all over the world who have a love of art. I hope every reader will find this book useful and have lots of fun painting with me.

Marina x

Drawing

Each step-by-step project is accompanied by a full-size line drawing for you to copy or trace onto your watercolour paper.

You don't need much to get started – the essentials are a few pencils and an eraser. It's important to keep your pencils sharp to get a fine mark – this will help to keep your paint clean.

You can work freehand or trace and transfer the image as you prefer.

If working freehand, use a sharp H pencil and light pressure to ensure a faint line. The drawing should be only very faintly visible to ensure the best results – I suggest that you use an eraser to soften the lines still further before you begin.

Take care when using an eraser not to scuff the paper and try to limit the amount you use it as erasers can affect the quality of watercolour application.

I sometimes use a watercolour pencil to draw so that the pencil lines blend in with the wet paint.

Alternative techniques

To create the line drawings in this book, I have used a digital sketching app called Procreate, using a digital pencil brush to draw out the design. I then printed it on paper to trace onto my watercolour paper with a 2H pencil. This technique is best done with a lightbox, though taping your work to a window with plenty of light will work just as well. Drawing digitally and tracing is a particularly good method if you want to make your lines thinner and your shapes consistent.

Extra line drawings

The line drawings are also available to download free from the Bookmarked Hub:
www.bookmarkedhub.com
Search for this book by title or ISBN: the files can be found under 'Book Extras'. Membership of the Bookmarked online community is free.

Materials for painting

Brushes

Brushes are available in a range of shapes, sizes and materials. If you are a beginner, I recommend using round brushes with fine tips. Brush sizes vary greatly between brands, so always consider the area you are painting when selecting your brush. Also remember that the pressure of your hand will also change the thickness of your lines, regardless of what brush you are using.

 The projects in this book can all be painted using just two brushes: a smaller one for tiny details and outlines and another for everything else. I have used size 0 and size 12 Da Vinci College Round brushes.

Paint

There are two types of watercolour paints available: in pans or in tubes. I prefer to use pan paints for my work but the projects in this book can be painted using either.

 Watercolours also come in two qualities:

Artists' These contain richer pigments of colour but they tend to be a little more expensive.

Students' These are more affordable, and can be used in place of the artists' range, however the colours will seem a little dull in comparison.

I have used a mix of ranges for this book from the Winsor & Newton collection (see page 11), however feel free to experiment with different suppliers to see what works best for you. Remember that you can also mix pigments to create your own colours.

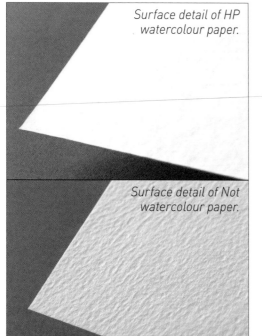

Surface detail of HP watercolour paper.

Surface detail of Not watercolour paper.

Paper

Normal cartridge paper will buckle or 'cockle' when wetted, so I always recommend that you use watercolour paper when painting. This is available in three different surface textures: Rough (heavily textured), Not which is short for 'not hot-pressed', sometimes called cold-pressed or CP (medium texture), and hot-pressed or HP (smooth texture).

 Watercolour paper also comes in a range of thicknesses, or weights. I have used 300gsm (140lb) paper for the projects in this book. I strongly recommend the Canson Montval watercolour paper range.

Water

Watercolour paints need to have water added – you dilute them on a palette to the strength you need for a particular area. How much water you use is dependent on how 'strong' or 'weak' you want your mix to be. The stronger the mix, the more paint you will use, and the weaker the mix, the more water you will use. It is always a good idea to practise your washes before you start your paintings.

When painting, I use jars of clean water to rinse my brushes and to avoid contaminating my colours. It is important to change your water regularly as dirty water can impact your painting.

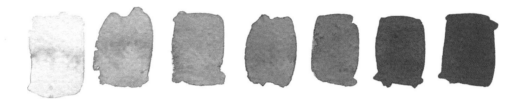

The same pigment at different dilutions.

Masking fluid

Before...

I have used masking fluid on a few of the projects in this book. It is used to retain an area of white paper for highlights or to block out areas to paint later on.

I use a coloured masking fluid which is easier to see on white paper, however they often come in either white or clear. I would recommend having a separate brush for your masking fluid as it is difficult to completely clean from the fibres.

...After

When using, allow the fluid to completely dry before applying paint to the area. It should peel off easily when you are done.

Painting techniques

All of the animals in this book can be painted using the techniques detailed below.

Wet on dry

Working wet on dry means applying colour to a dry surface, which can be either clean paper or a previous wash that has fully dried. This technique is used to achieve clean applications of colour and is mostly used when glazing and when painting details (see below). Always work wet on dry unless the instructions state otherwise.

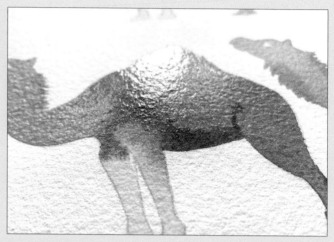

Wet into wet

Wet into wet is the technique of applying colour to a wet surface which has either been dampened with clean water or a previous wash. This technique is mostly used to blend multiple colours softly into each other and to create a smooth gradient of colour. The wetter the paper, the more the colours will bleed into each other. To create a subtler blend, wait until the paper is slightly damp (half-wet).

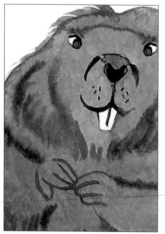

Painting details

Some animals, such as the beaver, require you to paint very small details and thin lines. To do this, make sure that the painting is completely dry, unless stated otherwise, and that you don't mix your paint with too much water. I always use my smallest brush to create these details, particularly the eyes.

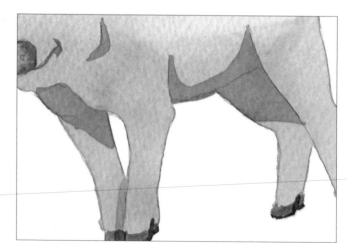

Glazing

Glazing is the technique of applying a wash (or glaze) of watercolour over an area of dry paint. This technique is often used to create shadows on the underside of the body and head. The number of layers you apply will impact how light or dark the area is. I recommend not using more than three layers of watercolour on the same area.

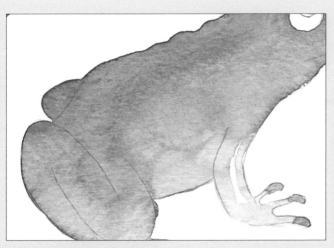

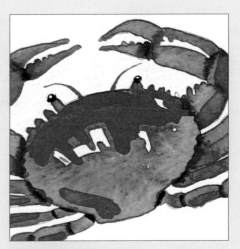

Wash

Most animals start with a base body colour. There are a few washes you can start with: a 'flat wash' is a single colour applied evenly so that it dries as a solid tone. A single colour applied so that it fades from dark to light is called a 'graduated wash'. A 'variegated wash' uses two or more colours which bleed together.

Highlights

Highlights are a great way to bring your painting to life. You can create these by either leaving the area free from paint, or using masking fluid to mark out the area and then rubbing it away when the paint is dry.

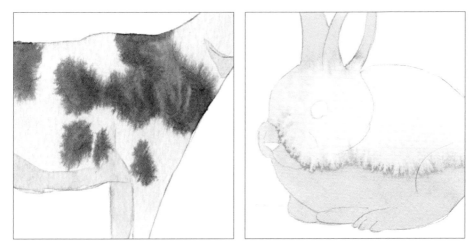

Dropping in

Dropping spots of colour on to a wet wash can be used to create markings and add texture. The pigment will bleed outwards and cause the colours to blend. The closer to the paper the brush is, the more control you will have over how the colour spreads. Dropping in water to an area will also cause your colours to lighten and diffuse.

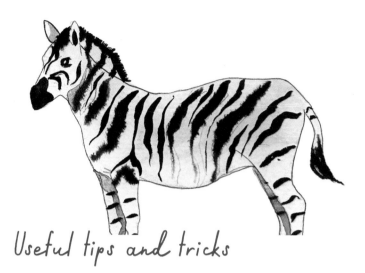

Useful tips and tricks

Here are some short pieces of advice to help you achieve the best results:

 There are some steps which should be done quickly and so it is best to read through the whole tutorial before you start to paint.

 Some steps need to be painted in order. These have been listed alphabetically within the step.

 Avoid using white watercolour paint. Try experimenting with light washes of colour instead.

 Use round natural brushes with fine tips for watercolour painting.

 Choose the correct size brush according to the size of the area you're going to paint.

 Use the paper as a tool: unpainted areas can be used to create highlights.

 Keep in mind that the colour of your paint will look more vibrant before it is dry.

 When drawing outlines, use a harder pencil (H or 2H work best) to make thinner lines and don't press down too hard.

 If your paint runs too much, use a cotton bud or a tissue to dab away excess colour.

10 Avoid using too much water.

11 Always work wet on dry unless the instructions state otherwise.

Colours

I always try to use pure colours wherever possible. Below is the list of colours I have used throughout this book. The colours you need for each project are listed alongside the instructions.

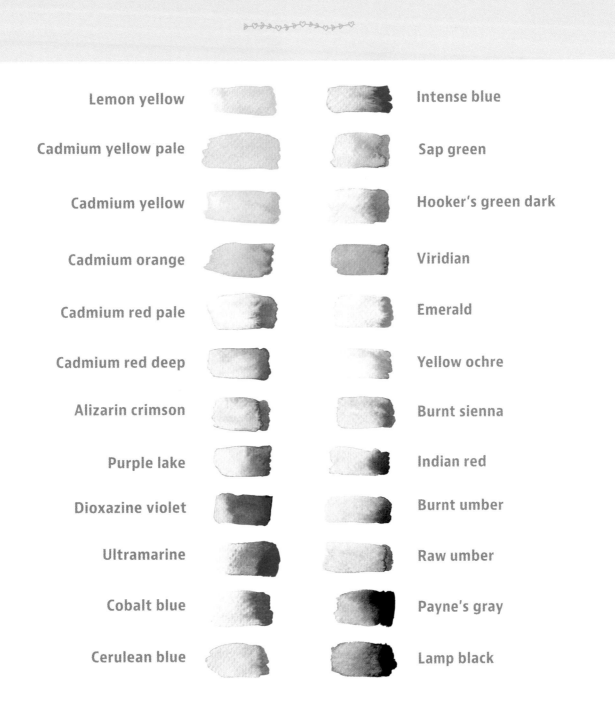

Lemon yellow	**Intense blue**
Cadmium yellow pale	**Sap green**
Cadmium yellow	**Hooker's green dark**
Cadmium orange	**Viridian**
Cadmium red pale	**Emerald**
Cadmium red deep	**Yellow ochre**
Alizarin crimson	**Burnt sienna**
Purple lake	**Indian red**
Dioxazine violet	**Burnt umber**
Ultramarine	**Raw umber**
Cobalt blue	**Payne's gray**
Cerulean blue	**Lamp black**

Llama

Drawing and colours

Transfer the line drawing to your watercolour paper as described on page 5.

Colours

 Raw umber

Cobalt blue

Payne's gray

Burnt umber

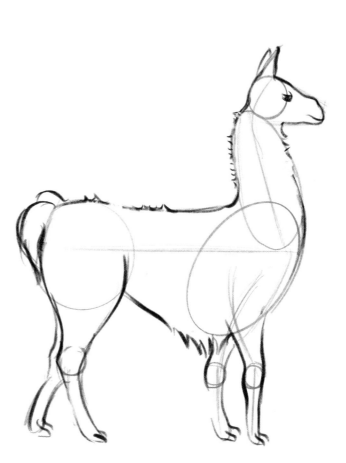

Painting

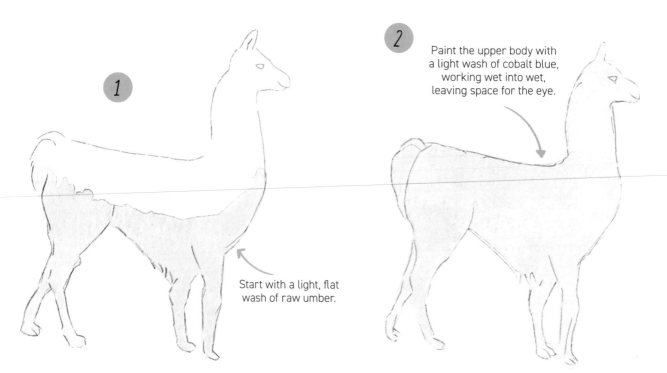

1

Start with a light, flat wash of raw umber.

2

Paint the upper body with a light wash of cobalt blue, working wet into wet, leaving space for the eye.

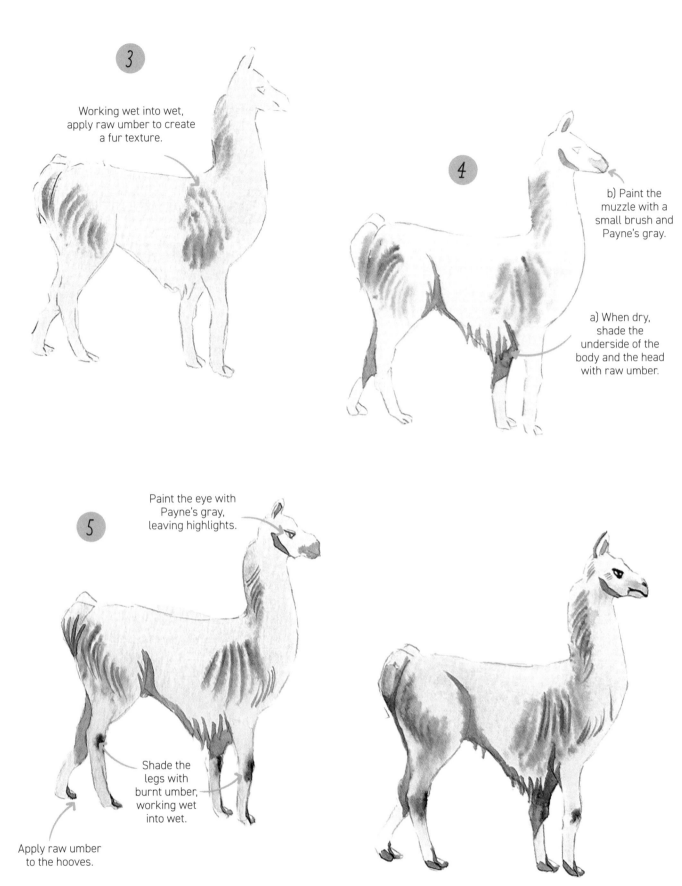

3

Working wet into wet, apply raw umber to create a fur texture.

4

b) Paint the muzzle with a small brush and Payne's gray.

a) When dry, shade the underside of the body and the head with raw umber.

5

Paint the eye with Payne's gray, leaving highlights.

Shade the legs with burnt umber, working wet into wet.

Apply raw umber to the hooves.

Once dry, add touches of Payne's gray to the hooves and the nostril and use raw umber to add additional texture to the fur.

Giraffe

Drawing and colours

Transfer the line drawing to your watercolour paper as described on page 5.

Colours

Burnt sienna

Yellow ochre

Payne's gray

Burnt umber

Painting

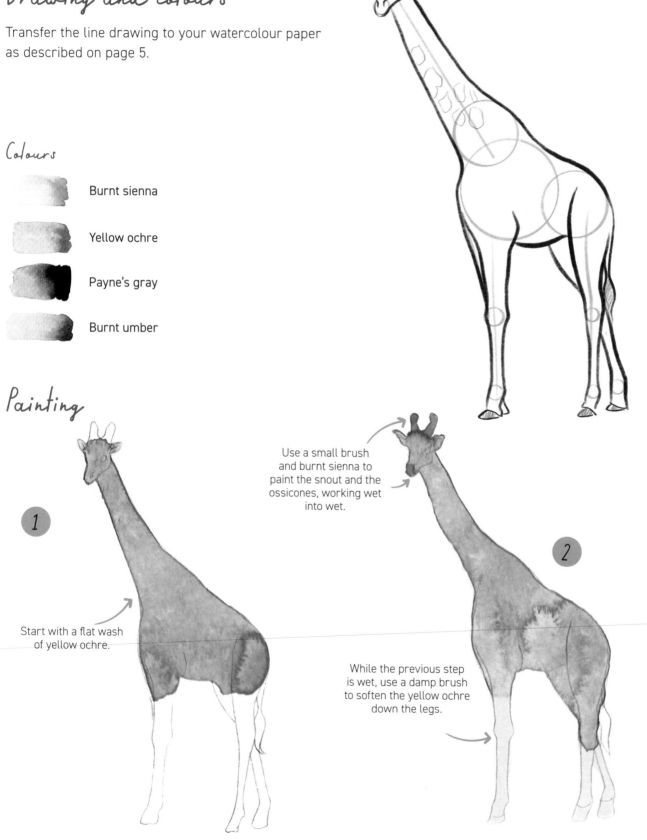

1

Start with a flat wash of yellow ochre.

Use a small brush and burnt sienna to paint the snout and the ossicones, working wet into wet.

2

While the previous step is wet, use a damp brush to soften the yellow ochre down the legs.

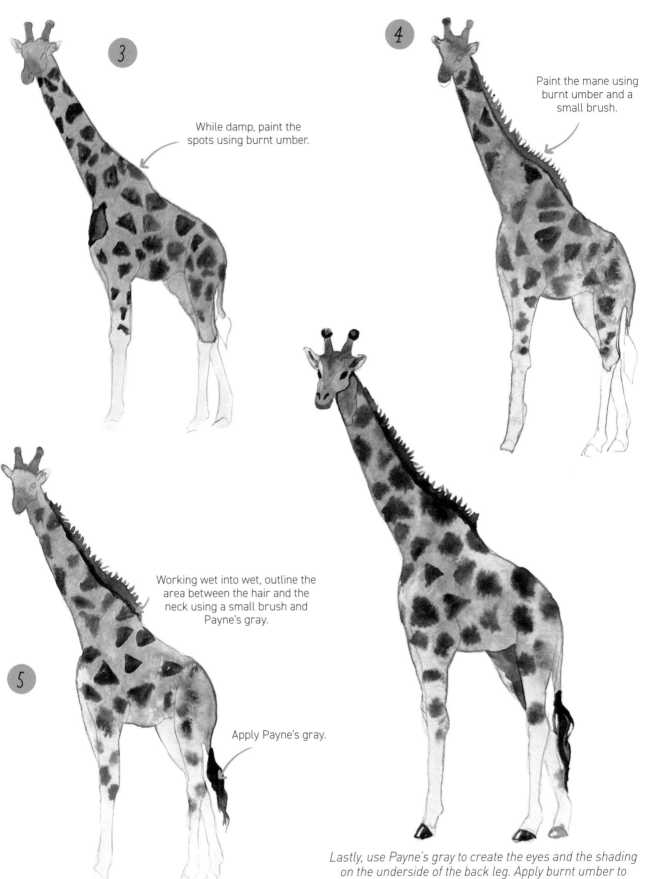

3

While damp, paint the spots using burnt umber.

4

Paint the mane using burnt umber and a small brush.

5

Working wet into wet, outline the area between the hair and the neck using a small brush and Payne's gray.

Apply Payne's gray.

Lastly, use Payne's gray to create the eyes and the shading on the underside of the back leg. Apply burnt umber to the inner ears and darken the forehead with burnt sienna. Apply a mix of burnt umber and Payne's gray to the hooves, leaving space for highlights.

Baby Deer

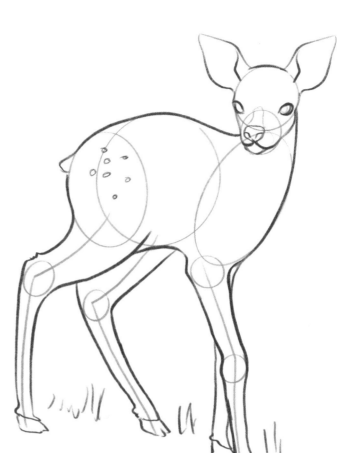

Drawing and colours

Transfer the line drawing to your watercolour paper as described on page 5. For this project you will need masking fluid.

Colours

Burnt sienna

Yellow ochre

Sap green

Burnt umber

Painting

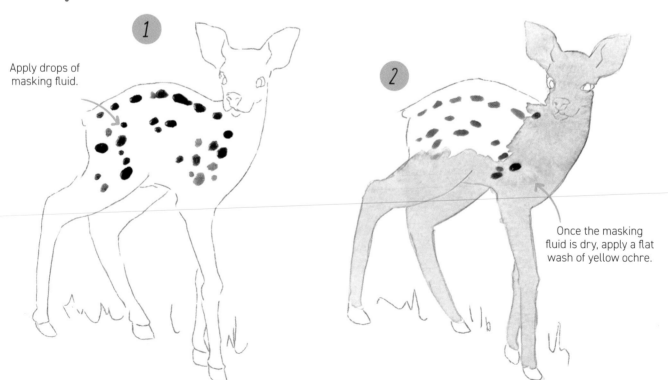

1

Apply drops of masking fluid.

2

Once the masking fluid is dry, apply a flat wash of yellow ochre.

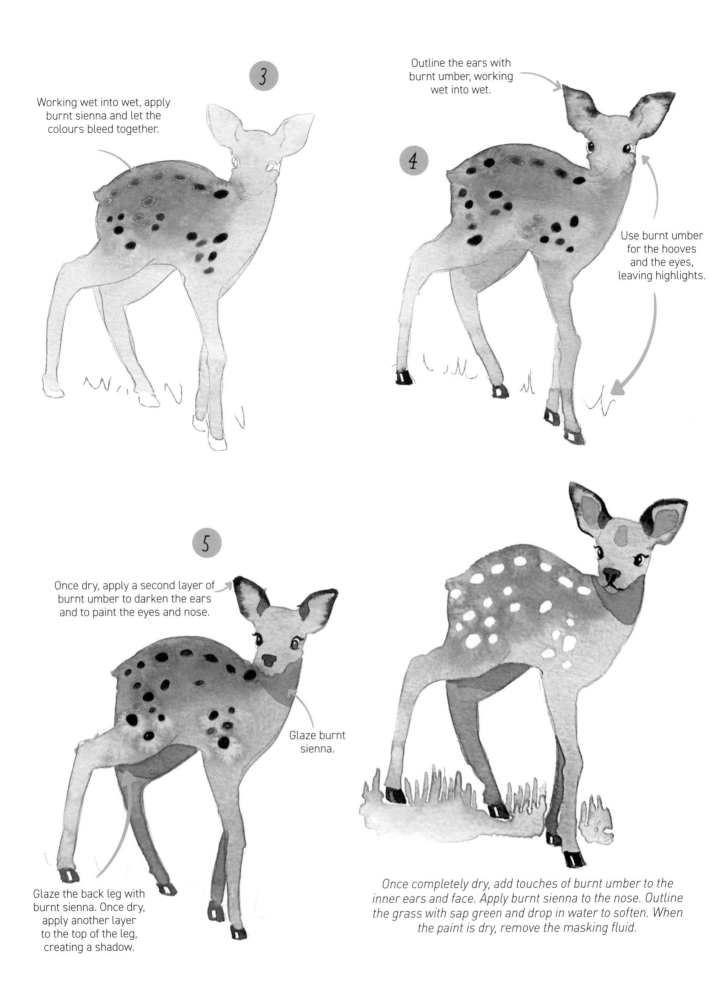

Working wet into wet, apply burnt sienna and let the colours bleed together.

3

Outline the ears with burnt umber, working wet into wet.

4

Use burnt umber for the hooves and the eyes, leaving highlights.

5

Once dry, apply a second layer of burnt umber to darken the ears and to paint the eyes and nose.

Glaze burnt sienna.

Glaze the back leg with burnt sienna. Once dry, apply another layer to the top of the leg, creating a shadow.

Once completely dry, add touches of burnt umber to the inner ears and face. Apply burnt sienna to the nose. Outline the grass with sap green and drop in water to soften. When the paint is dry, remove the masking fluid.

Hippopotamus

Drawing and colours

Transfer the line drawing to your watercolour paper as described on page 5.

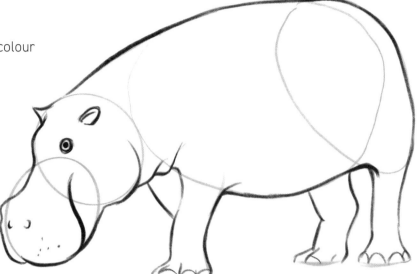

Colours

 Payne's gray

 Purple lake

Painting

a) Apply a flat wash of Payne's gray to the upper body, avoiding the side of the head.

1

b) Paint the lower body with a flat wash of purple lake, working wet into wet, so the colours bleed together.

2

While the previous step is wet, drop in purple lake to the side of the head.

Dot along the body using Payne's gray, working wet into wet.

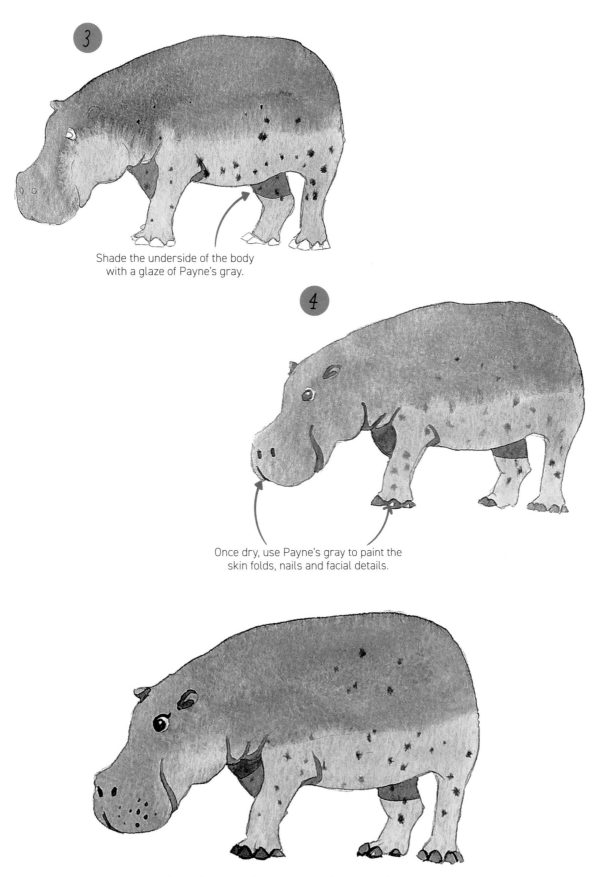

Shade the underside of the body with a glaze of Payne's gray.

Once dry, use Payne's gray to paint the skin folds, nails and facial details.

Finally, add a second layer of Payne's gray to the eyes, nostrils and toes to define their shape.

Cow

Drawing and colours

Transfer the line drawing to your watercolour paper as described on page 5.

Colours

Raw umber

Alizarin crimson

Payne's gray

Burnt umber

Painting

Begin with a light, flat wash of raw umber.

While the previous step is wet, drop in spots of Payne's gray to create the markings.

Paint the tail with Payne's gray, working wet into wet, leaving highlights.

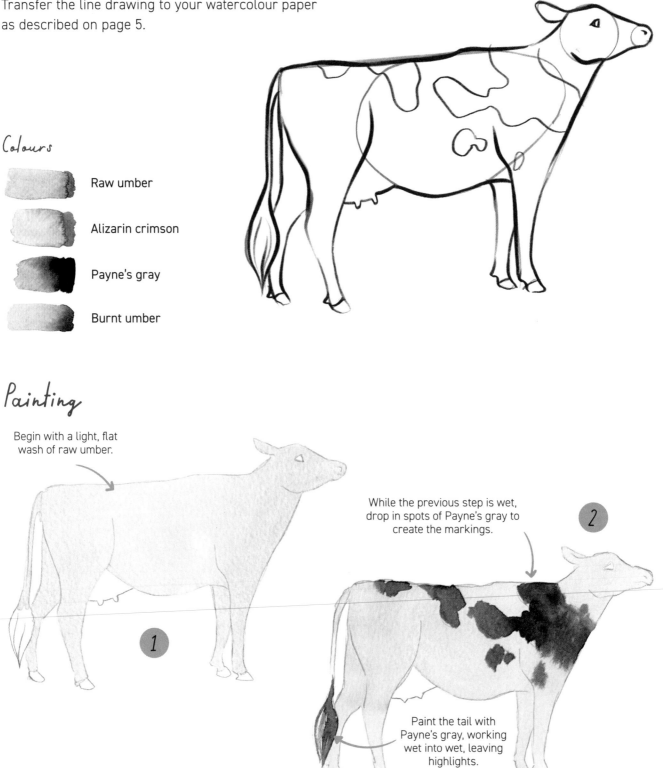

1

2

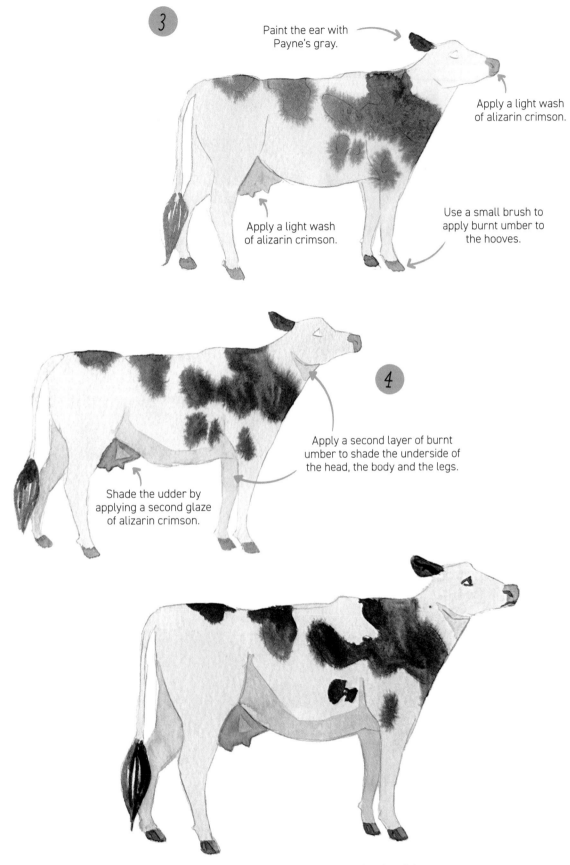

3

Paint the ear with Payne's gray.

Apply a light wash of alizarin crimson.

Apply a light wash of alizarin crimson.

Use a small brush to apply burnt umber to the hooves.

4

Apply a second layer of burnt umber to shade the underside of the head, the body and the legs.

Shade the udder by applying a second glaze of alizarin crimson.

Lastly, add touches of burnt umber to the backs of the hooves and to create the facial details.

Dog

Drawing and colours

Transfer the line drawing to
your watercolour paper as
described on page 5.

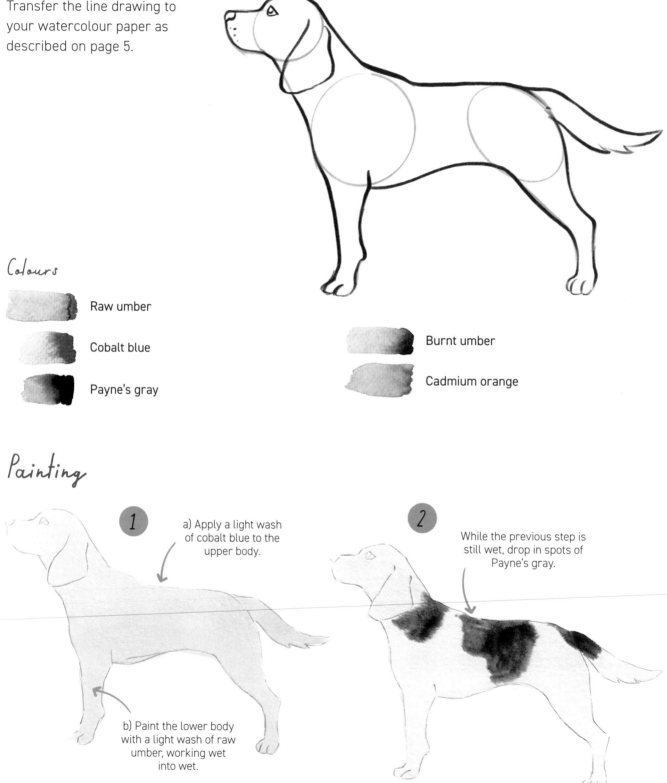

Colours

Raw umber

Cobalt blue

Payne's gray

Burnt umber

Cadmium orange

Painting

1

a) Apply a light wash
of cobalt blue to the
upper body.

b) Paint the lower body
with a light wash of raw
umber, working wet
into wet.

2

While the previous step is
still wet, drop in spots of
Payne's gray.

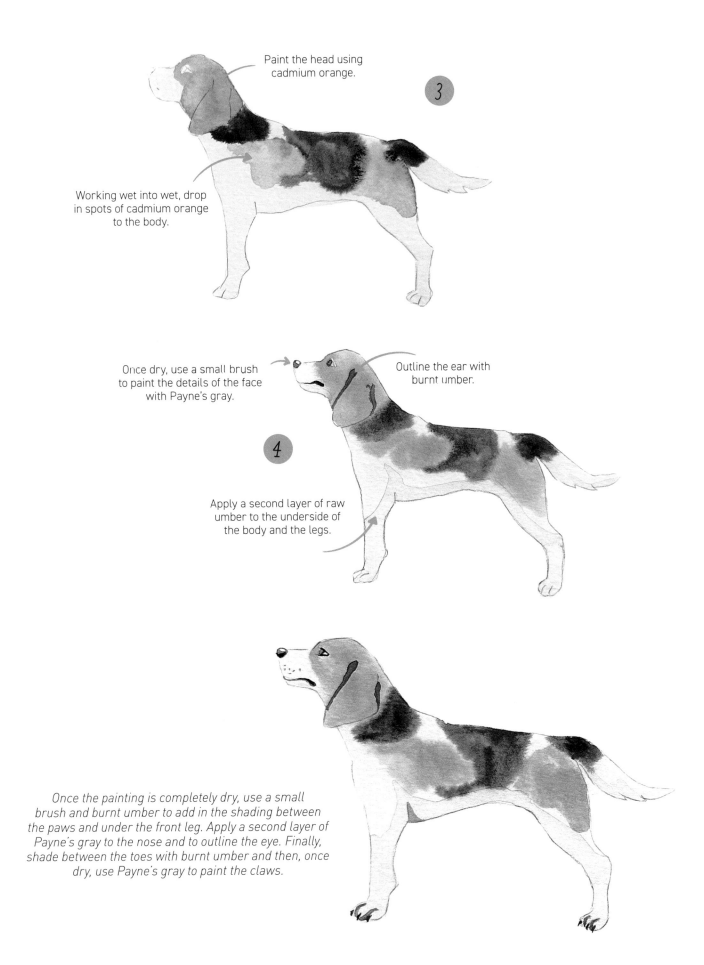

Paint the head using cadmium orange.

3

Working wet into wet, drop in spots of cadmium orange to the body.

Once dry, use a small brush to paint the details of the face with Payne's gray.

Outline the ear with burnt umber.

4

Apply a second layer of raw umber to the underside of the body and the legs.

Once the painting is completely dry, use a small brush and burnt umber to add in the shading between the paws and under the front leg. Apply a second layer of Payne's gray to the nose and to outline the eye. Finally, shade between the toes with burnt umber and then, once dry, use Payne's gray to paint the claws.

Polar Bear

Drawing and colours

Transfer the line drawing to your watercolour paper as described on page 5.

Colours

Purple lake

Cobalt blue

Payne's gray

Yellow ochre

Painting

1 Paint the head and neck with a light wash of cobalt blue.

2 Working wet into wet, apply a pale wash of purple lake to the upper body, leaving highlights.

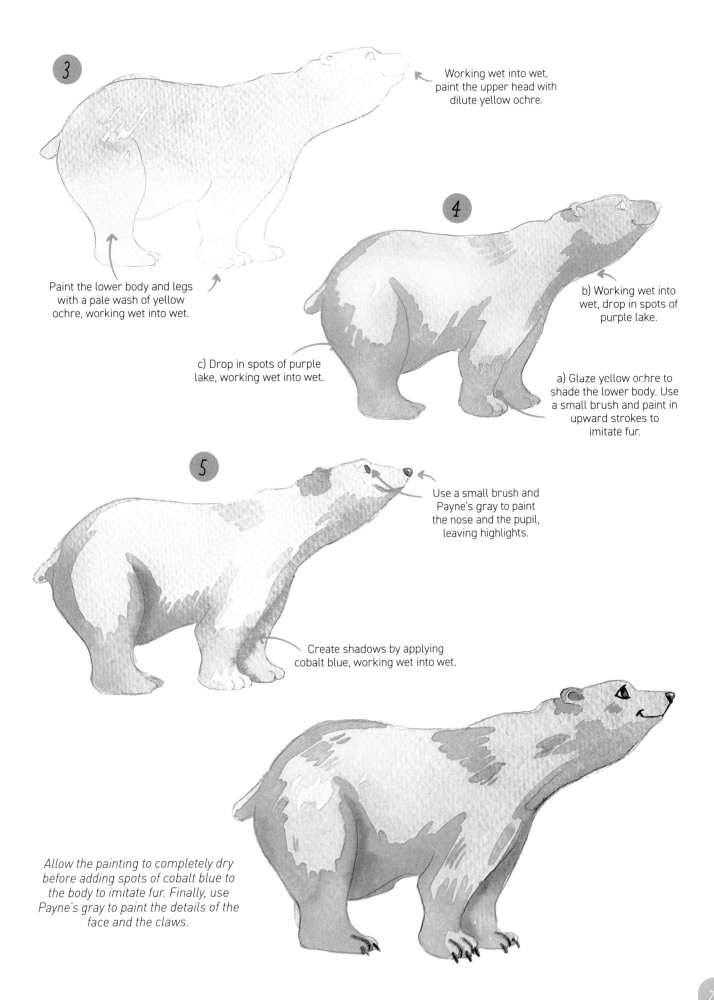

3

Working wet into wet, paint the upper head with dilute yellow ochre.

Paint the lower body and legs with a pale wash of yellow ochre, working wet into wet.

4

b) Working wet into wet, drop in spots of purple lake.

c) Drop in spots of purple lake, working wet into wet.

a) Glaze yellow ochre to shade the lower body. Use a small brush and paint in upward strokes to imitate fur.

5

Use a small brush and Payne's gray to paint the nose and the pupil, leaving highlights.

Create shadows by applying cobalt blue, working wet into wet.

Allow the painting to completely dry before adding spots of cobalt blue to the body to imitate fur. Finally, use Payne's gray to paint the details of the face and the claws.

Camel

Drawing and colours

Transfer the line drawing to your watercolour paper as described on page 5.

Colours

Yellow ochre

Raw umber

Burnt umber

Payne's gray

Painting

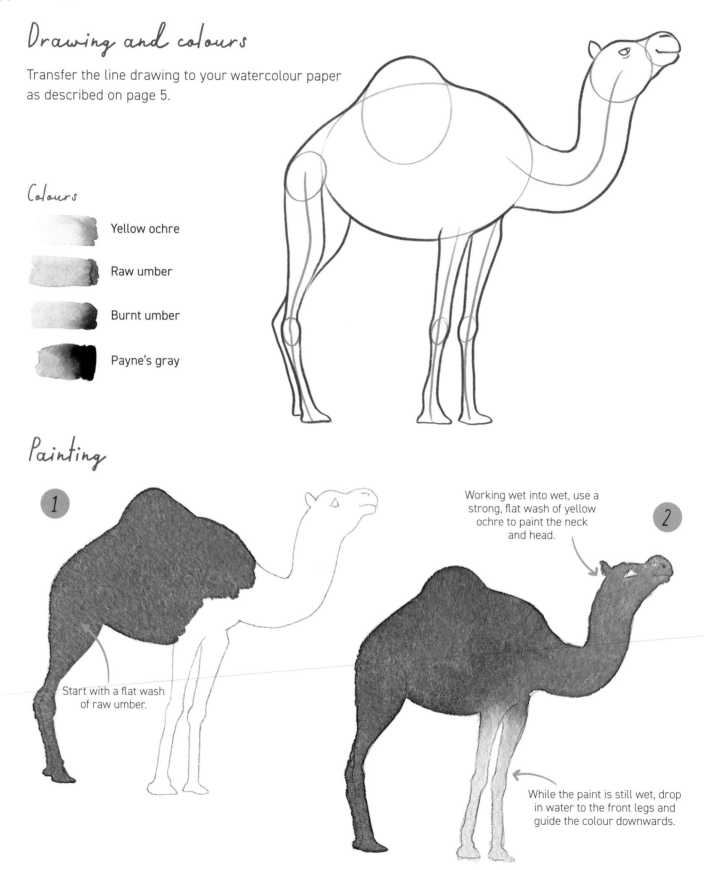

1

Start with a flat wash of raw umber.

Working wet into wet, use a strong, flat wash of yellow ochre to paint the neck and head.

2

While the paint is still wet, drop in water to the front legs and guide the colour downwards.

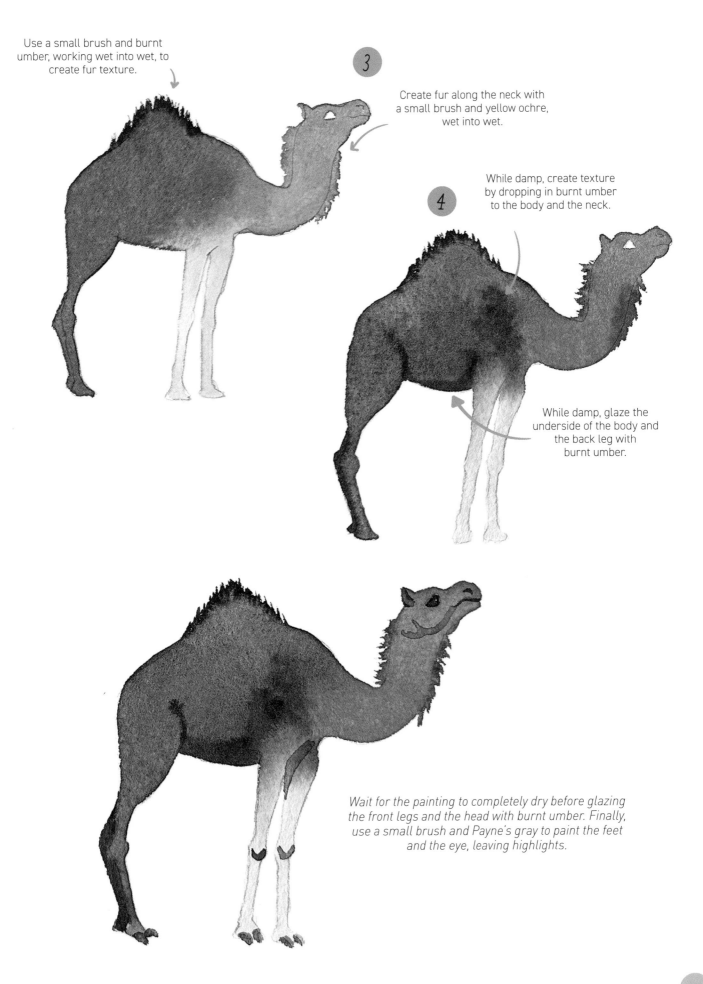

Use a small brush and burnt umber, working wet into wet, to create fur texture.

3

Create fur along the neck with a small brush and yellow ochre, wet into wet.

4

While damp, create texture by dropping in burnt umber to the body and the neck.

While damp, glaze the underside of the body and the back leg with burnt umber.

Wait for the painting to completely dry before glazing the front legs and the head with burnt umber. Finally, use a small brush and Payne's gray to paint the feet and the eye, leaving highlights.

Panda

Drawing and colours

Transfer the line drawing to your watercolour paper as described on page 5.

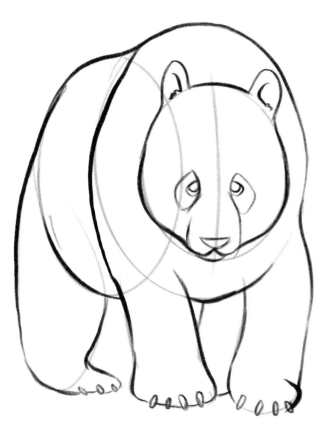

Colours

 Payne's gray

 Yellow ochre

Painting

1

Start by applying a wash of yellow ochre to the lower head and the midsection.

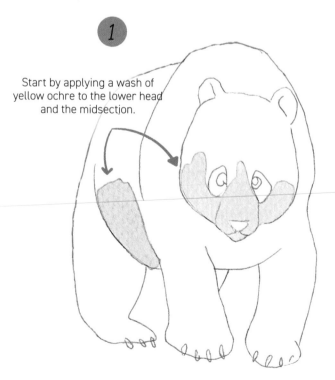

2

Drop in water to diffuse the yellow ochre upwards.

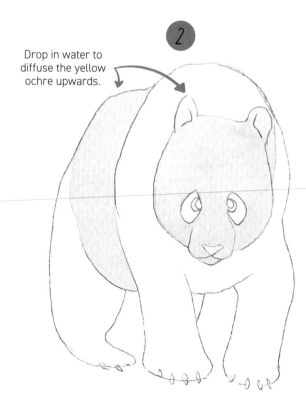

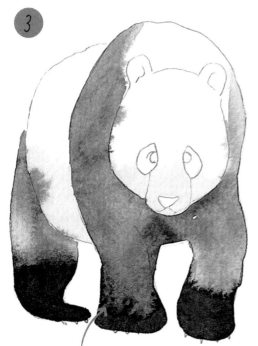

3

Paint the rest of the body with Payne's gray on half-wet, using a darker pigment towards the paws and painting upwards.

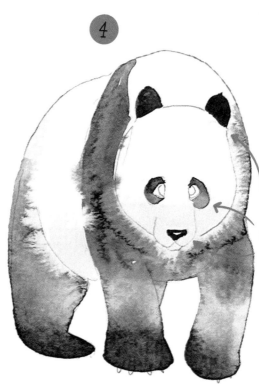

4

Once dry, use a small brush and Payne's gray to paint the ears, the nose and around the eyes.

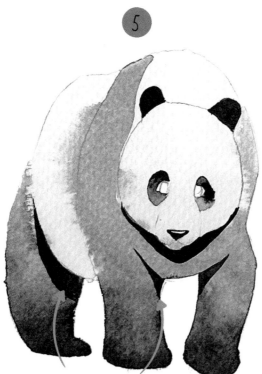

5

Glaze Payne's gray under the head and the lower body to create shadows.

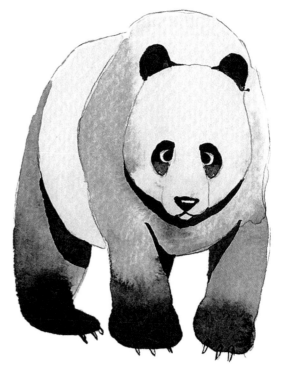

Once dry, finish by painting the claws, the eyes and the mouth with Payne's gray.

Deer

Drawing and colours

Transfer the line drawing to your watercolour paper as described on page 5.

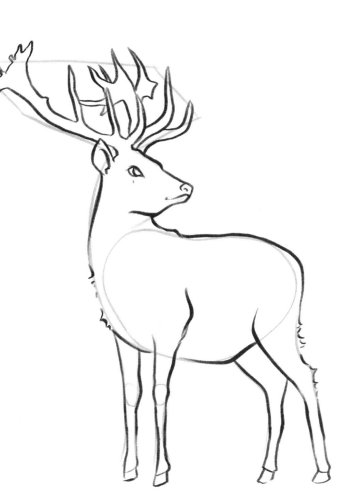

Colours

 Raw umber

 Indian red

Payne's gray

 Burnt umber

Painting

Start with a flat wash of burnt umber, leaving a space for the eye.

1

Working wet into wet, apply Indian red to the rest of the body, allowing the colours to bleed together.

2

③

c) Use a small brush to paint the tops of the antlers with raw umber, working wet into wet.

b) Use a small brush to outline the ear with Payne's gray, working wet into wet.

a) Paint the bottom of the antlers with a light mix of Payne's gray, working wet into wet.

④

Once completely dry, use a small brush to paint the eye and nose in Payne's gray, leaving highlights.

Glaze the underside of the body and the legs with burnt umber to create shadows.

Use Payne's gray for the hooves, leaving highlights.

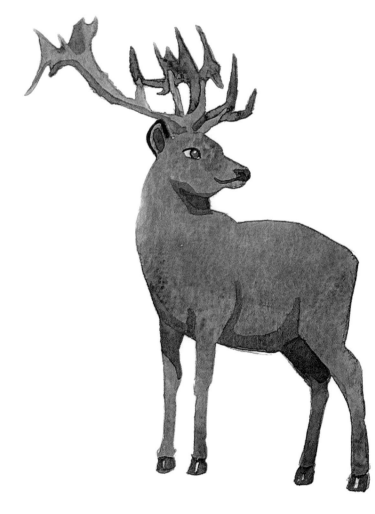

Add a second glaze of Payne's gray to the hooves, nose and mouth, leaving highlights. Shade the left antler with raw umber and use Payne's gray to shade the right. Finally, apply a second glaze of burnt umber to the underside of the head and the legs.

Woodpecker

Drawing and colours

Transfer the line drawing to your watercolour paper as described on page 5.

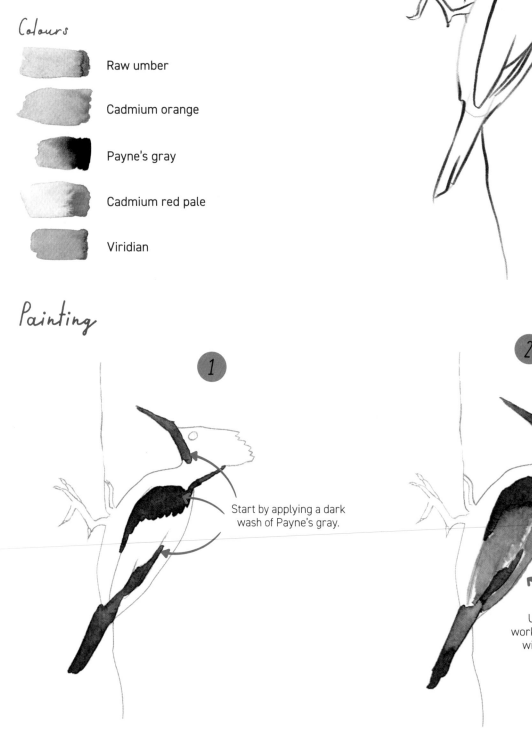

Colours

Raw umber

Cadmium orange

Payne's gray

Cadmium red pale

Viridian

Painting

1

Start by applying a dark wash of Payne's gray.

2

Use cadmium orange, working wet into wet, for the wing, leaving highlights.

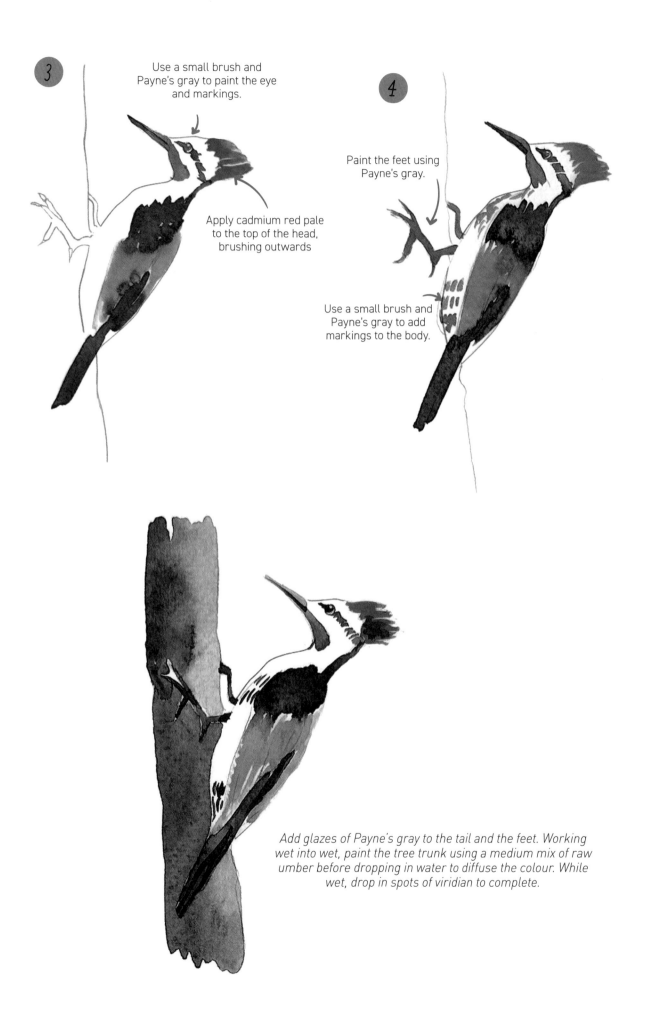

3 Use a small brush and Payne's gray to paint the eye and markings.

Apply cadmium red pale to the top of the head, brushing outwards

4 Paint the feet using Payne's gray.

Use a small brush and Payne's gray to add markings to the body.

Add glazes of Payne's gray to the tail and the feet. Working wet into wet, paint the tree trunk using a medium mix of raw umber before dropping in water to diffuse the colour. While wet, drop in spots of viridian to complete.

Frog

Drawing and colours

Transfer the line drawing to your watercolour paper as described on page 5.

Colours

Viridian

Alizarin crimson

Payne's gray

Intense blue

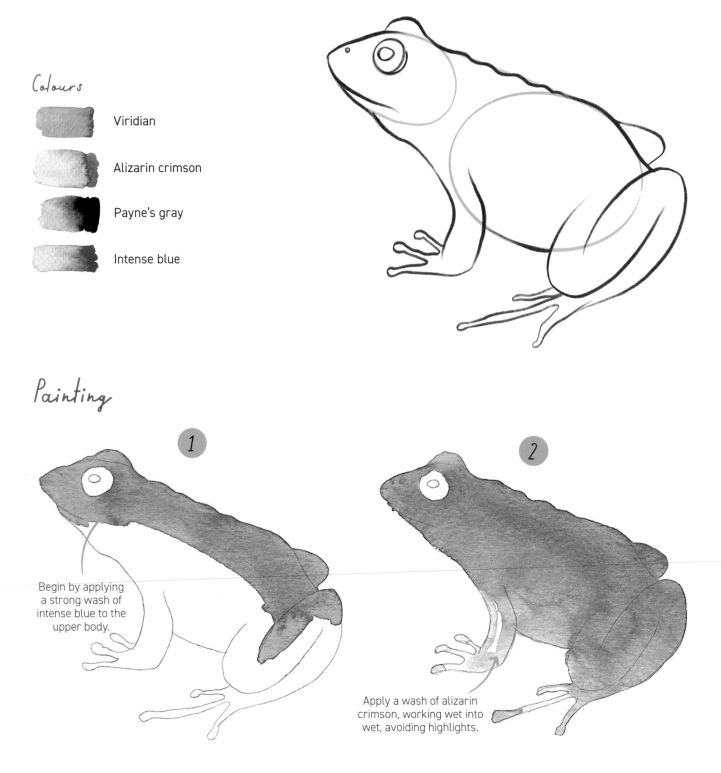

Painting

1

Begin by applying a strong wash of intense blue to the upper body.

2

Apply a wash of alizarin crimson, working wet into wet, avoiding highlights.

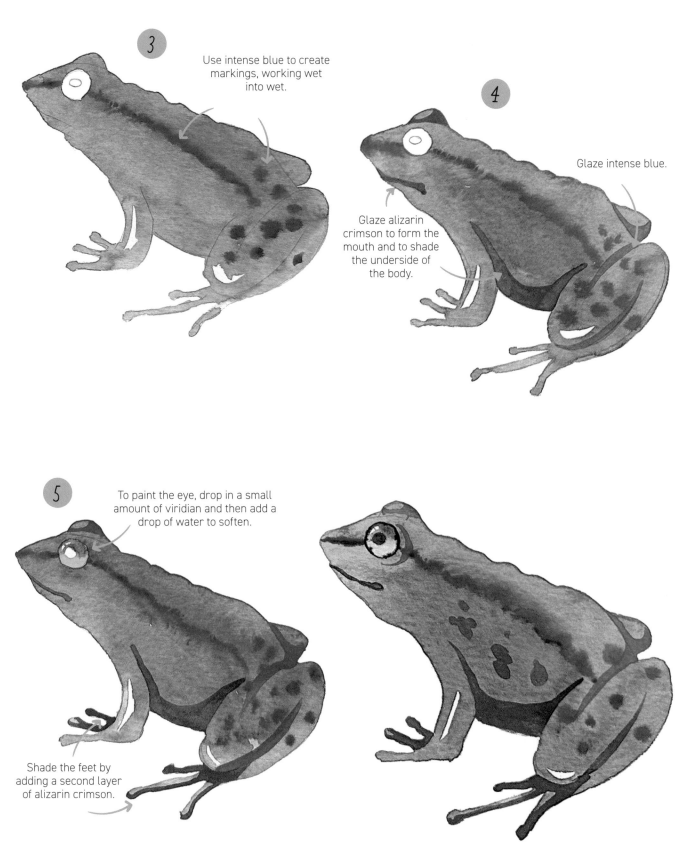

3

Use intense blue to create markings, working wet into wet.

4

Glaze alizarin crimson to form the mouth and to shade the underside of the body.

Glaze intense blue.

5

To paint the eye, drop in a small amount of viridian and then add a drop of water to soften.

Shade the feet by adding a second layer of alizarin crimson.

Using a small brush, encircle the eye and add the pupil with Payne's gray, working wet into wet. Finally, add texture to the body by dropping in spots of alizarin crimson.

Shark

Drawing and colours

Transfer the line drawing to your watercolour paper as described on page 5.

Colours

Ultramarine

Cerulean blue

Payne's gray

Painting

Begin by applying a strong wash of cerulean blue.

1

Drop water into the wet paint to diffuse the cerulean blue towards the upper body.

2

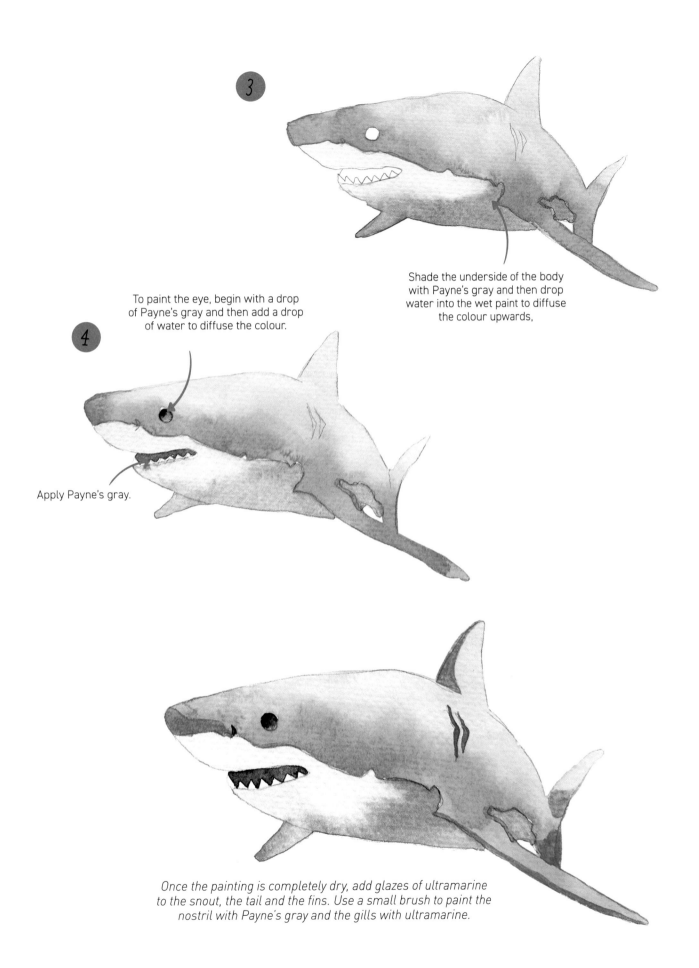

3

Shade the underside of the body with Payne's gray and then drop water into the wet paint to diffuse the colour upwards,

4

To paint the eye, begin with a drop of Payne's gray and then add a drop of water to diffuse the colour.

Apply Payne's gray.

Once the painting is completely dry, add glazes of ultramarine to the snout, the tail and the fins. Use a small brush to paint the nostril with Payne's gray and the gills with ultramarine.

Gecko

Drawing and colours

Transfer the line drawing to your watercolour paper as described on page 5.

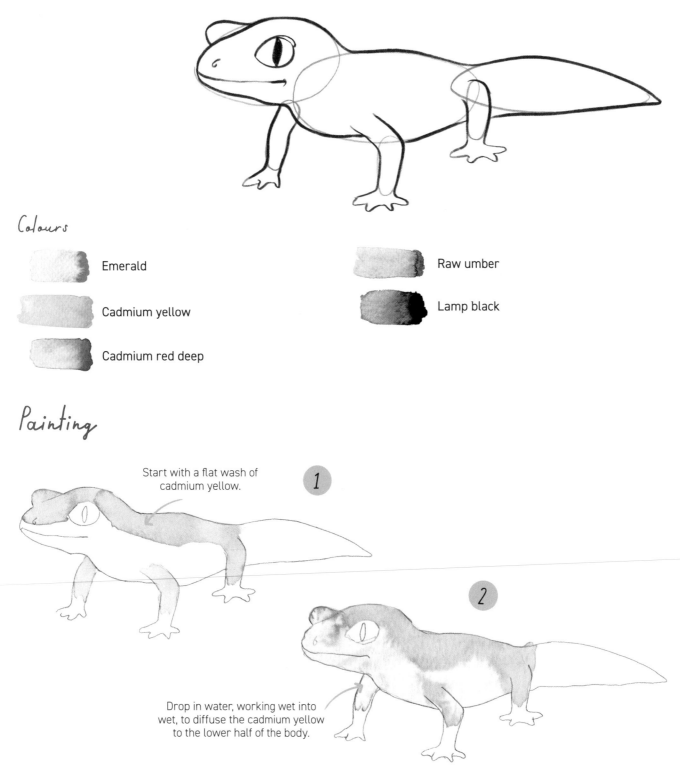

Colours

Emerald

Cadmium yellow

Cadmium red deep

Raw umber

Lamp black

Painting

Start with a flat wash of cadmium yellow.

1

2

Drop in water, working wet into wet, to diffuse the cadmium yellow to the lower half of the body.

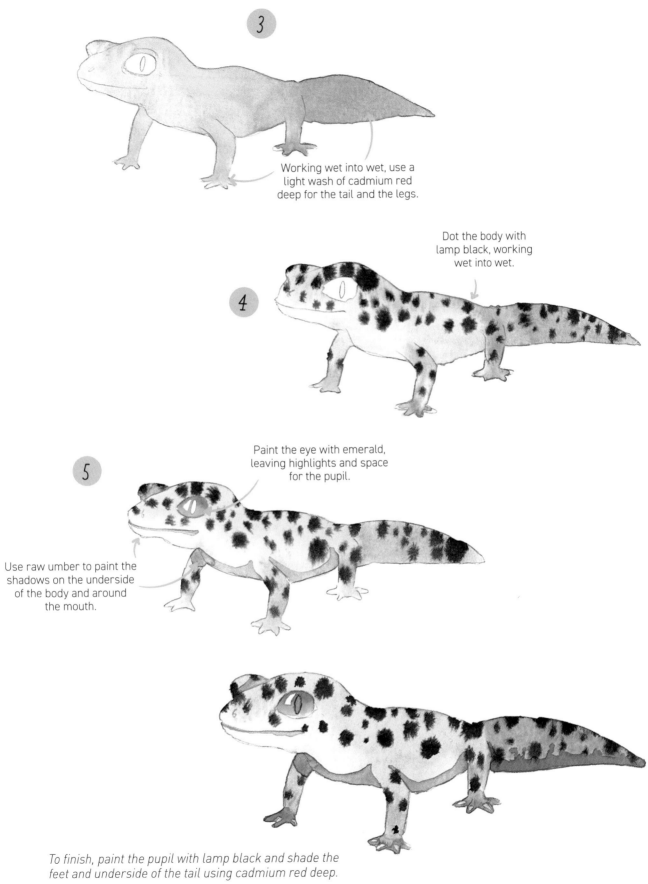

3

Working wet into wet, use a light wash of cadmium red deep for the tail and the legs.

Dot the body with lamp black, working wet into wet.

4

Paint the eye with emerald, leaving highlights and space for the pupil.

5

Use raw umber to paint the shadows on the underside of the body and around the mouth.

To finish, paint the pupil with lamp black and shade the feet and underside of the tail using cadmium red deep.

Seal

Drawing and colours

Transfer the line drawing to your watercolour paper as described on page 5.

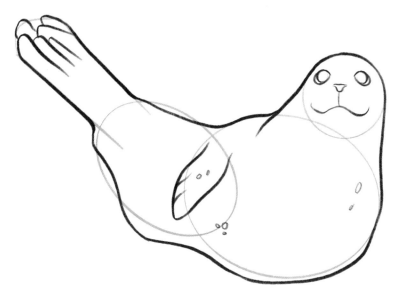

Colours

 Raw umber

Burnt sienna

Payne's gray

Burnt umber

Painting

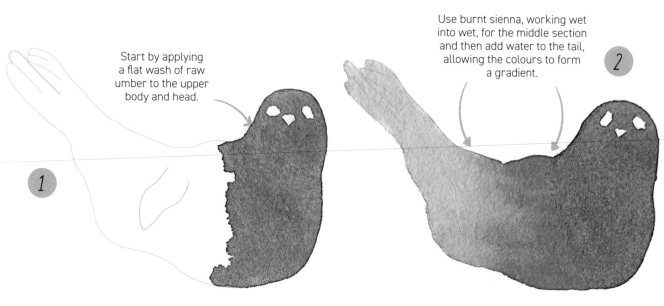

Start by applying a flat wash of raw umber to the upper body and head.

Use burnt sienna, working wet into wet, for the middle section and then add water to the tail, allowing the colours to form a gradient.

1

2

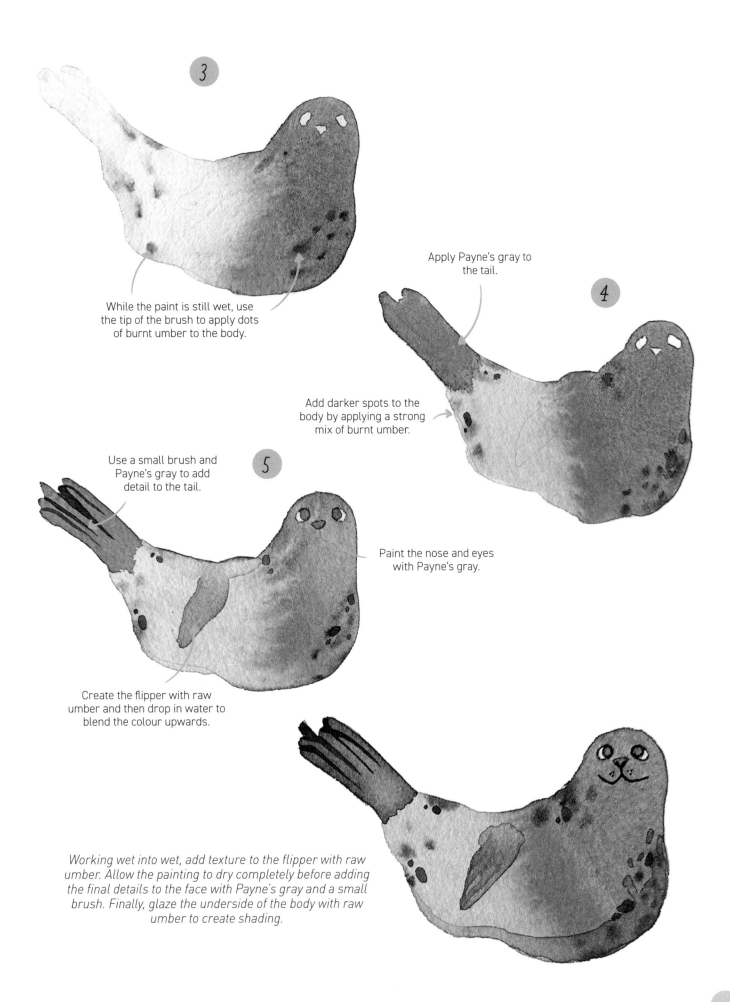

3

While the paint is still wet, use the tip of the brush to apply dots of burnt umber to the body.

4

Apply Payne's gray to the tail.

Add darker spots to the body by applying a strong mix of burnt umber.

5

Use a small brush and Payne's gray to add detail to the tail.

Paint the nose and eyes with Payne's gray.

Create the flipper with raw umber and then drop in water to blend the colour upwards.

Working wet into wet, add texture to the flipper with raw umber. Allow the painting to dry completely before adding the final details to the face with Payne's gray and a small brush. Finally, glaze the underside of the body with raw umber to create shading.

Goat

Drawing and colours

Transfer the line drawing to your watercolour paper as described on page 5.

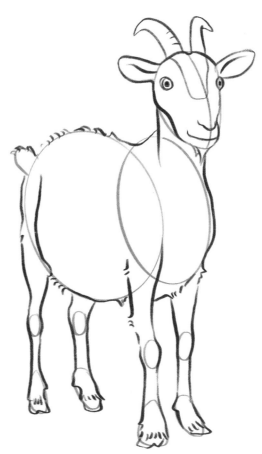

Colours

 Cadmium yellow pale

Yellow ochre

 Burnt sienna

Burnt umber

Lamp black

Painting

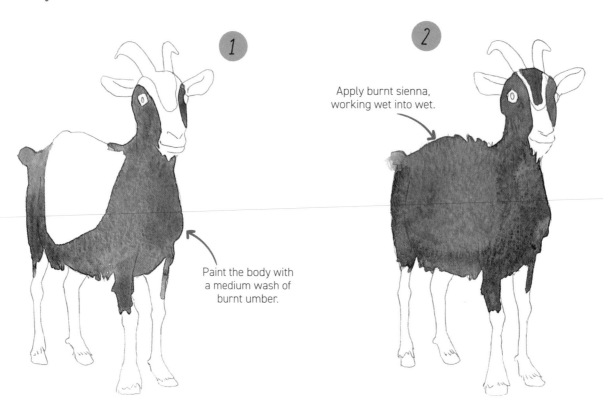

1

Paint the body with a medium wash of burnt umber.

2

Apply burnt sienna, working wet into wet.

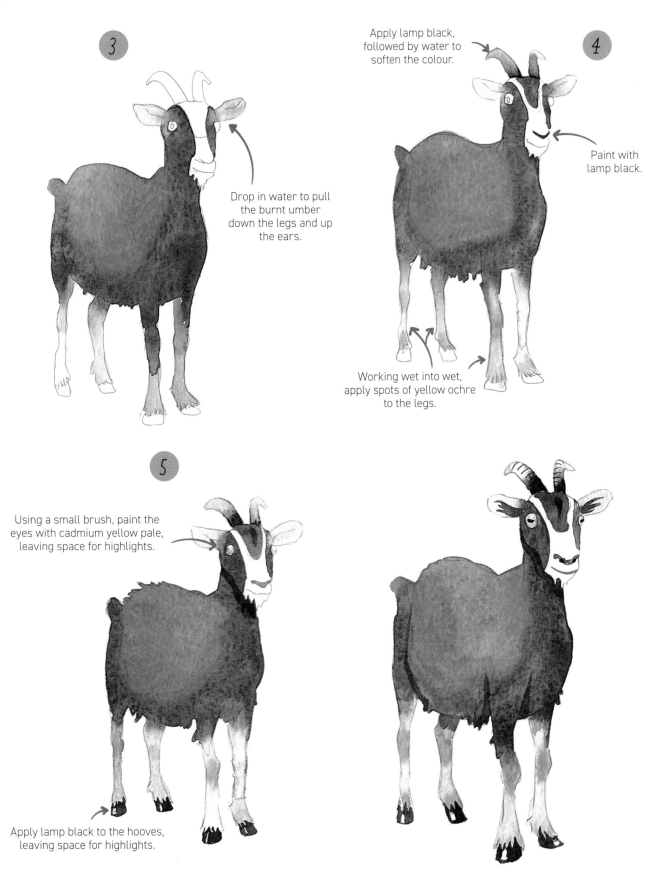

3

Drop in water to pull the burnt umber down the legs and up the ears.

4

Apply lamp black, followed by water to soften the colour.

Paint with lamp black.

Working wet into wet, apply spots of yellow ochre to the legs.

5

Using a small brush, paint the eyes with cadmium yellow pale, leaving space for highlights.

Apply lamp black to the hooves, leaving space for highlights.

Use a small brush to detail the horns, the nose, and the pupils. Define the body shape with burnt umber to finish.

Koi Carp

Drawing and colours

Transfer the line drawing to your watercolour paper as described on page 5.

Colours

 Payne's gray

 Cadmium red pale

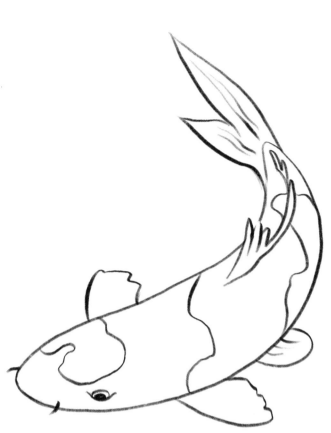

Painting

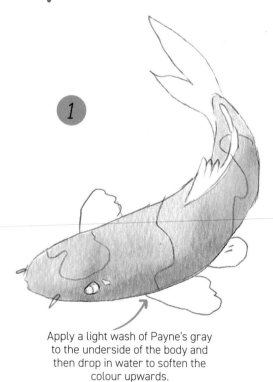

1

Apply a light wash of Payne's gray to the underside of the body and then drop in water to soften the colour upwards.

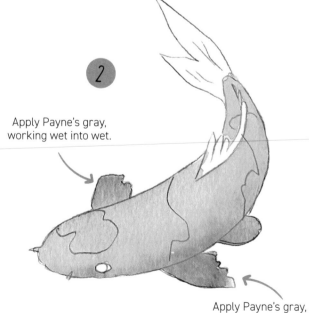

2

Apply Payne's gray, working wet into wet.

Apply Payne's gray, working wet into wet.

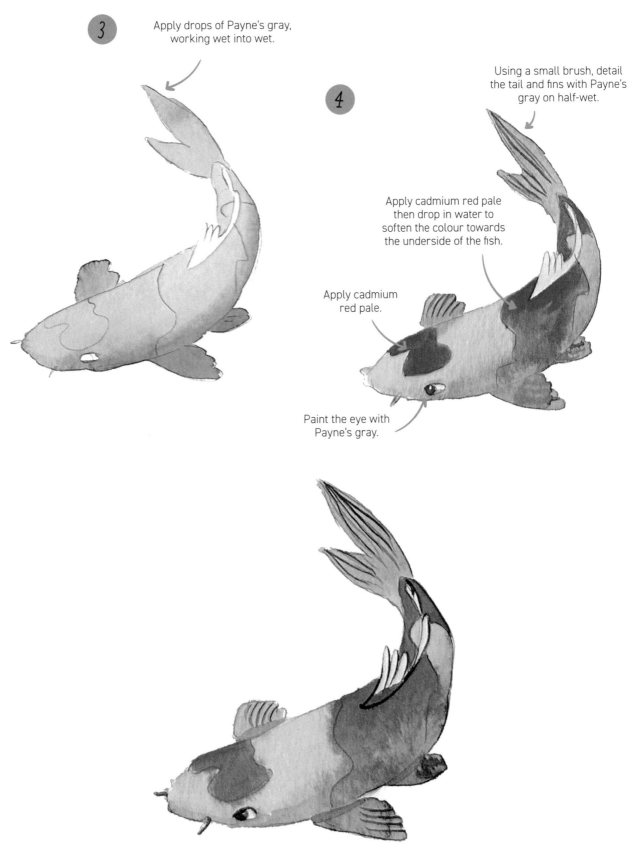

3 Apply drops of Payne's gray, working wet into wet.

4 Using a small brush, detail the tail and fins with Payne's gray on half-wet.

Apply cadmium red pale then drop in water to soften the colour towards the underside of the fish.

Apply cadmium red pale.

Paint the eye with Payne's gray.

Using a small brush and Payne's gray, outline the eye and add details to the fins and tail.

Sloth

Drawing and colours

Transfer the line drawing to your watercolour paper as described on page 5.

Colours

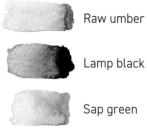

Raw umber

Lamp black

Sap green

Burnt umber

Painting

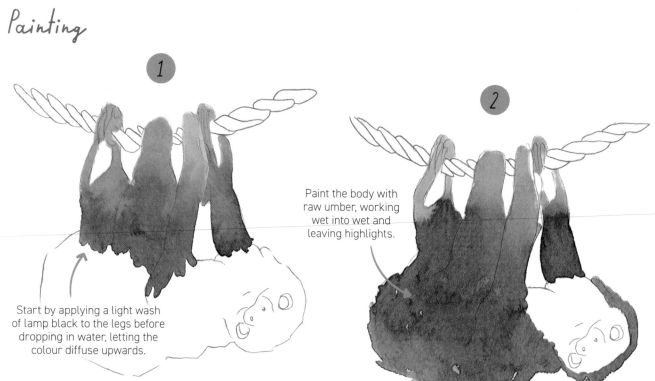

1

Start by applying a light wash of lamp black to the legs before dropping in water, letting the colour diffuse upwards.

2

Paint the body with raw umber, working wet into wet and leaving highlights.

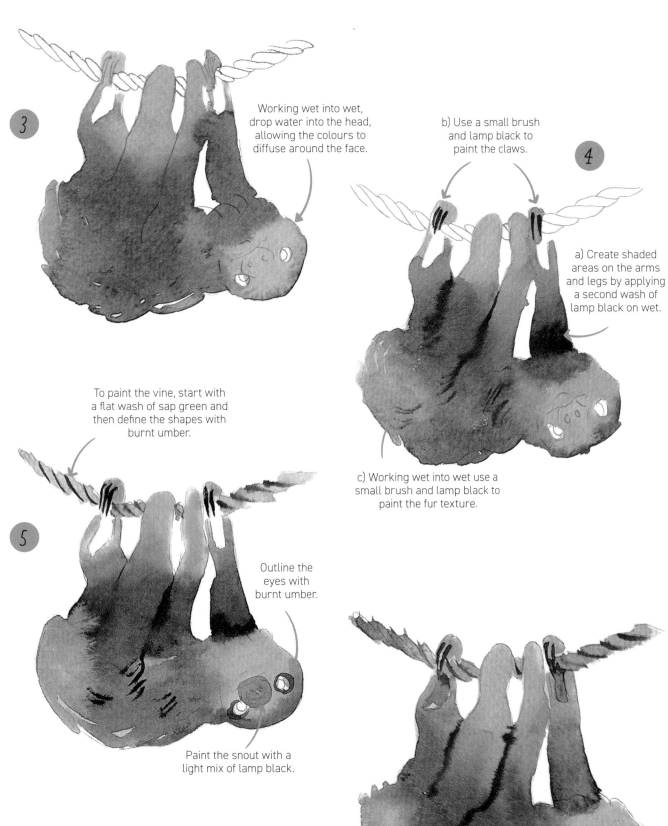

3

Working wet into wet,
drop water into the head,
allowing the colours to
diffuse around the face.

b) Use a small brush
and lamp black to
paint the claws.

4

a) Create shaded
areas on the arms
and legs by applying
a second wash of
lamp black on wet.

c) Working wet into wet use a
small brush and lamp black to
paint the fur texture.

To paint the vine, start with
a flat wash of sap green and
then define the shapes with
burnt umber.

5

Outline the
eyes with
burnt umber.

Paint the snout with a
light mix of lamp black.

*Paint the pads of the back legs and arms with burnt umber.
Lastly, use lamp black to add the final details to the face:
the mouth, eyes and nostrils.*

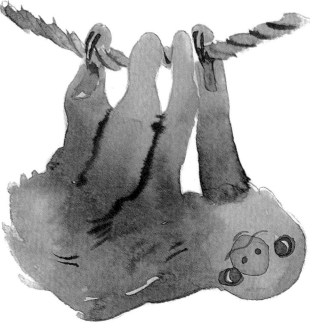

Meerkat

Drawing and colours

Transfer the line drawing to your watercolour paper as described on page 5.

Colours

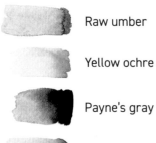

Raw umber

Yellow ochre

Payne's gray

Burnt umber

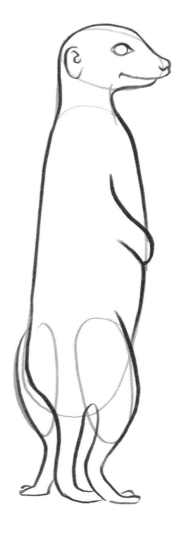

Painting

Paint the upper body using a flat wash of raw umber.

1

2

Working wet into wet, apply a flat wash of yellow ochre to the lower half of the body, allowing it to bleed upwards.

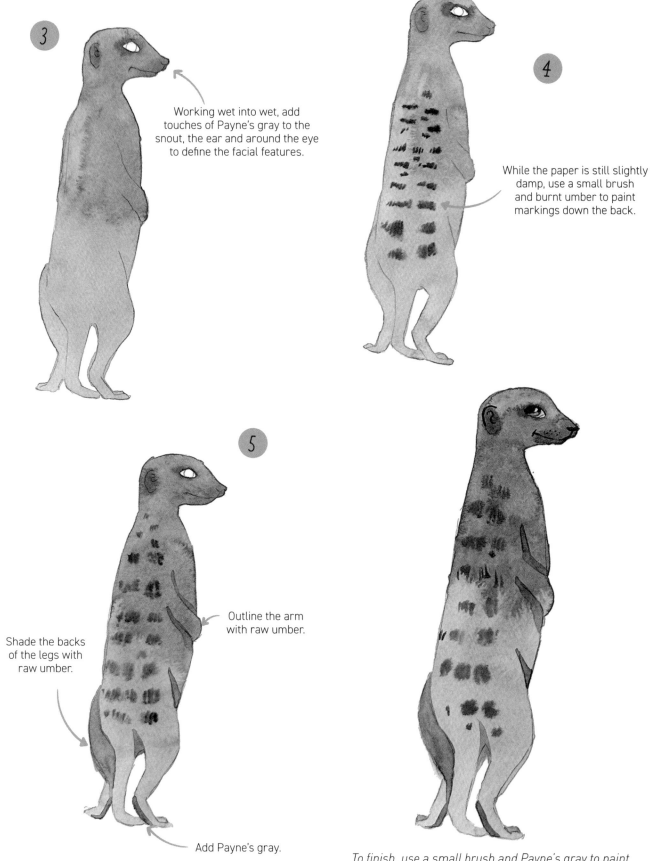

3

Working wet into wet, add touches of Payne's gray to the snout, the ear and around the eye to define the facial features.

4

While the paper is still slightly damp, use a small brush and burnt umber to paint markings down the back.

5

Shade the backs of the legs with raw umber.

Outline the arm with raw umber.

Add Payne's gray.

To finish, use a small brush and Payne's gray to paint the facial details: the nose, eye, ear and mouth.

Beaver

Drawing and colours

Transfer the line drawing to your watercolour paper as described on page 5.

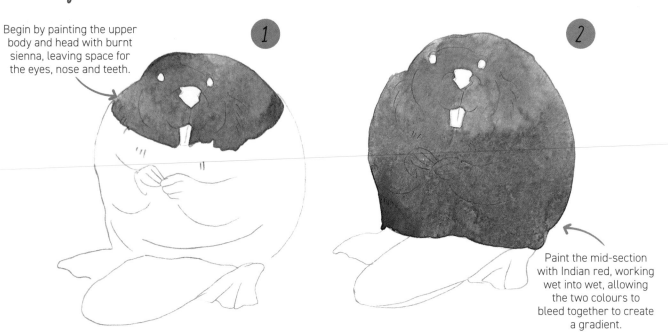

Colours

Indian red

Burnt sienna

Payne's gray

Burnt umber

Painting

Begin by painting the upper body and head with burnt sienna, leaving space for the eyes, nose and teeth.

1

2

Paint the mid-section with Indian red, working wet into wet, allowing the two colours to bleed together to create a gradient.

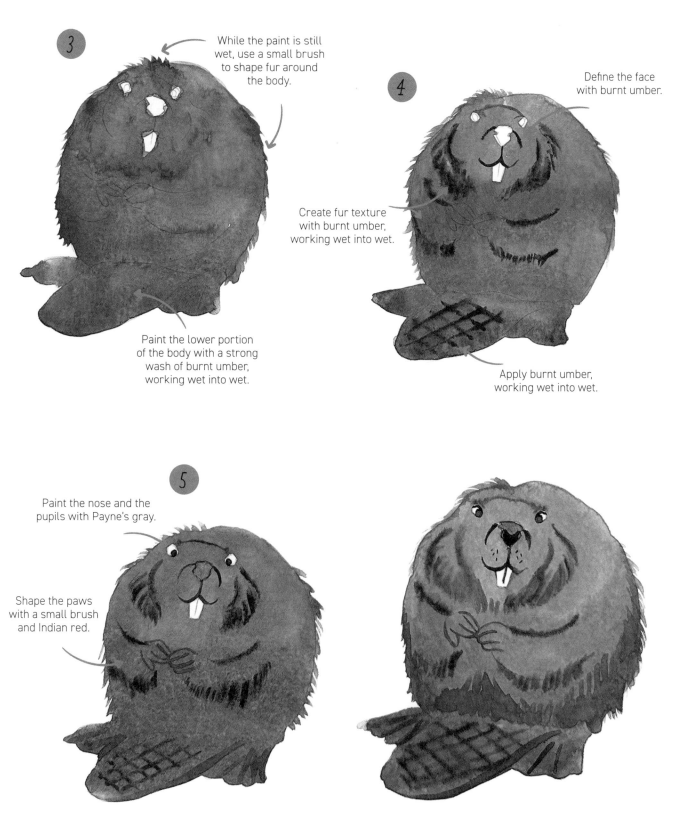

3

While the paint is still wet, use a small brush to shape fur around the body.

Paint the lower portion of the body with a strong wash of burnt umber, working wet into wet.

4

Define the face with burnt umber.

Create fur texture with burnt umber, working wet into wet.

Apply burnt umber, working wet into wet.

5

Paint the nose and the pupils with Payne's gray.

Shape the paws with a small brush and Indian red.

To finish, add touches of Indian red to create a fur texture around the lower body. Lastly, use a small brush and Payne's gray to define the eyes and darken the nose.

Crab

Drawing and colours

Transfer the line drawing to your watercolour paper as described on page 5.

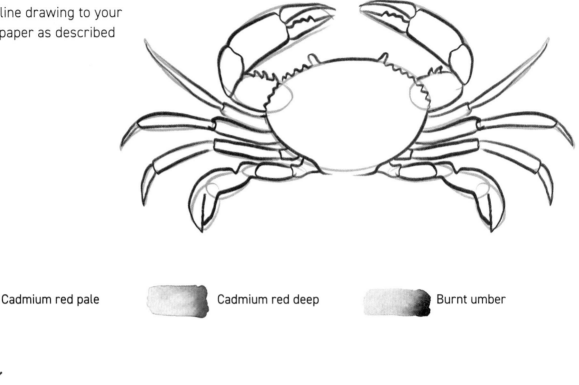

Colours

Cadmium red pale

Cadmium red deep

Burnt umber

Painting

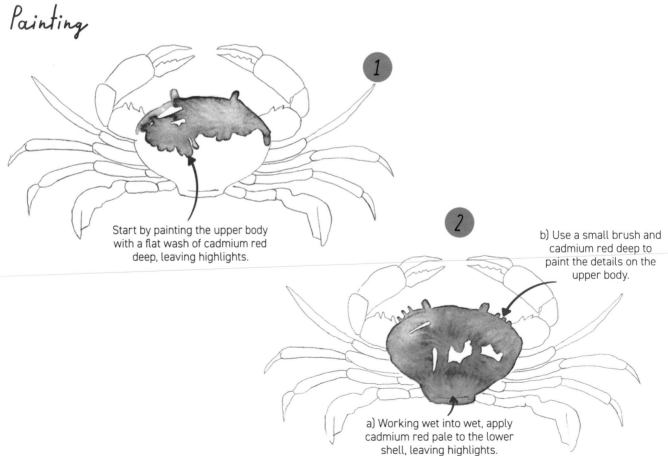

1

Start by painting the upper body with a flat wash of cadmium red deep, leaving highlights.

2

b) Use a small brush and cadmium red deep to paint the details on the upper body.

a) Working wet into wet, apply cadmium red pale to the lower shell, leaving highlights.

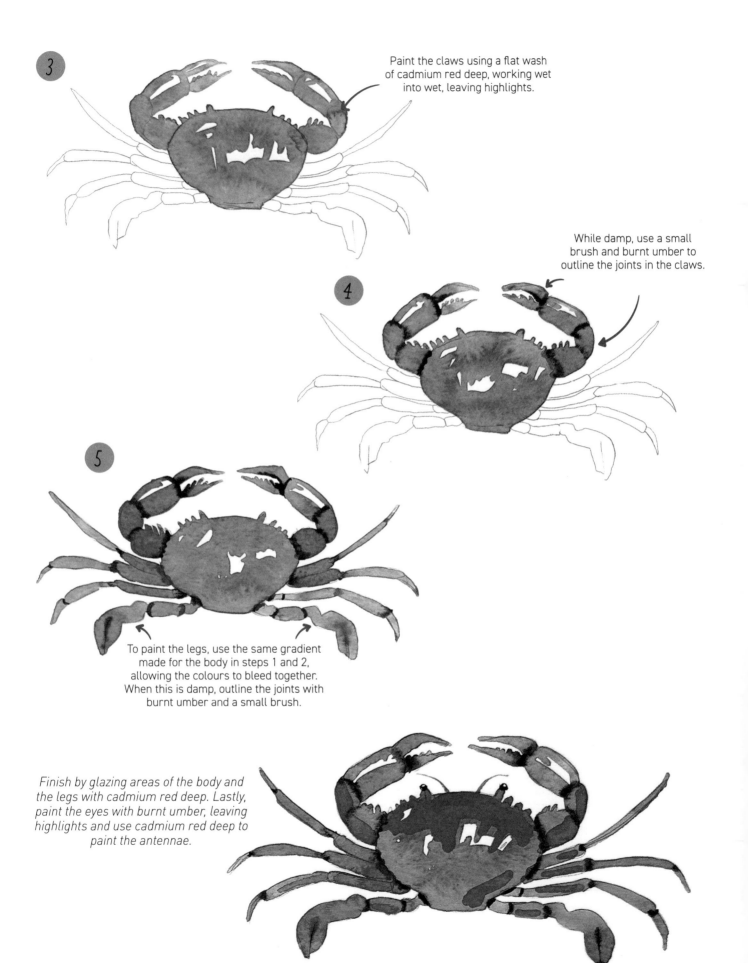

3

Paint the claws using a flat wash of cadmium red deep, working wet into wet, leaving highlights.

While damp, use a small brush and burnt umber to outline the joints in the claws.

4

5

To paint the legs, use the same gradient made for the body in steps 1 and 2, allowing the colours to bleed together. When this is damp, outline the joints with burnt umber and a small brush.

Finish by glazing areas of the body and the legs with cadmium red deep. Lastly, paint the eyes with burnt umber, leaving highlights and use cadmium red deep to paint the antennae.

Seagull

Drawing and colours

Transfer the line drawing to your watercolour paper as described on page 5.

Colours

	Ultramarine
	Yellow ochre
	Purple lake
	Cadmium red pale
	Cadmium yellow
	Payne's gray
	Burnt umber

Painting

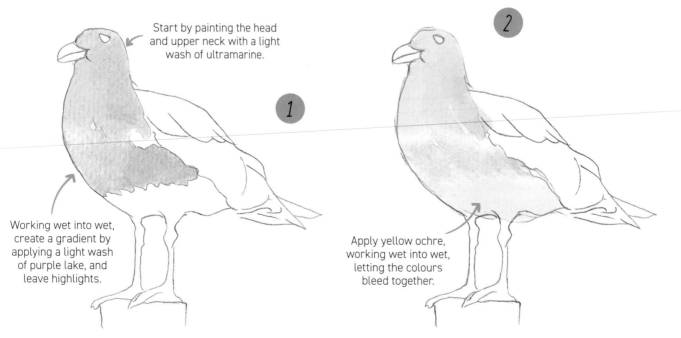

Start by painting the head and upper neck with a light wash of ultramarine.

Working wet into wet, create a gradient by applying a light wash of purple lake, and leave highlights.

Apply yellow ochre, working wet into wet, letting the colours bleed together.

1

2

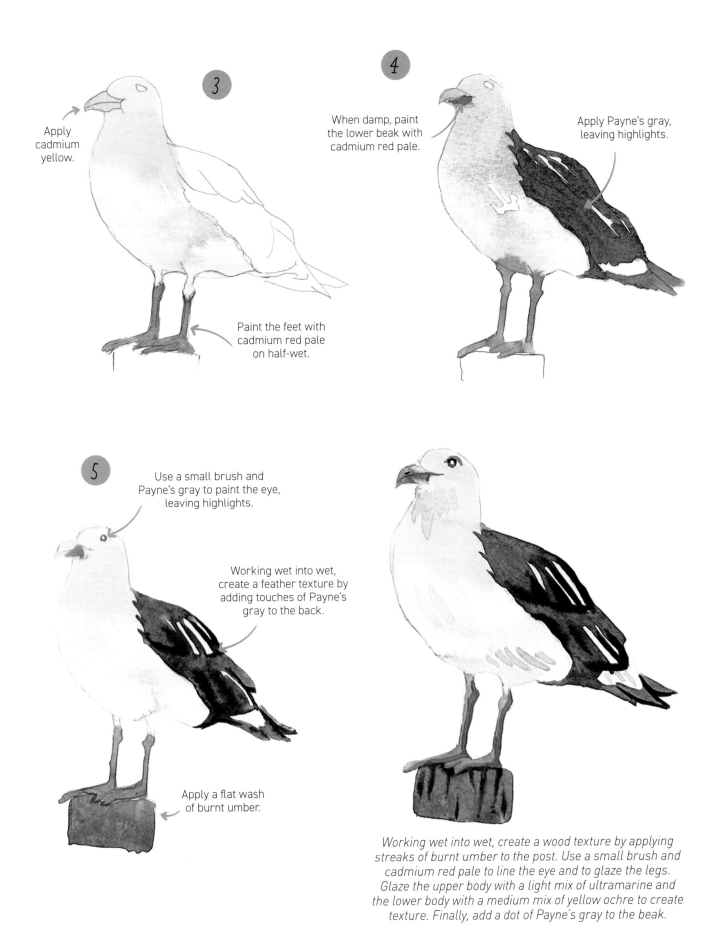

3

Apply cadmium yellow.

When damp, paint the lower beak with cadmium red pale.

Apply Payne's gray, leaving highlights.

Paint the feet with cadmium red pale on half-wet.

4

5

Use a small brush and Payne's gray to paint the eye, leaving highlights.

Working wet into wet, create a feather texture by adding touches of Payne's gray to the back.

Apply a flat wash of burnt umber.

Working wet into wet, create a wood texture by applying streaks of burnt umber to the post. Use a small brush and cadmium red pale to line the eye and to glaze the legs. Glaze the upper body with a light mix of ultramarine and the lower body with a medium mix of yellow ochre to create texture. Finally, add a dot of Payne's gray to the beak.

Stork

Drawing and colours

Transfer the line drawing to your watercolour paper as described on page 5.

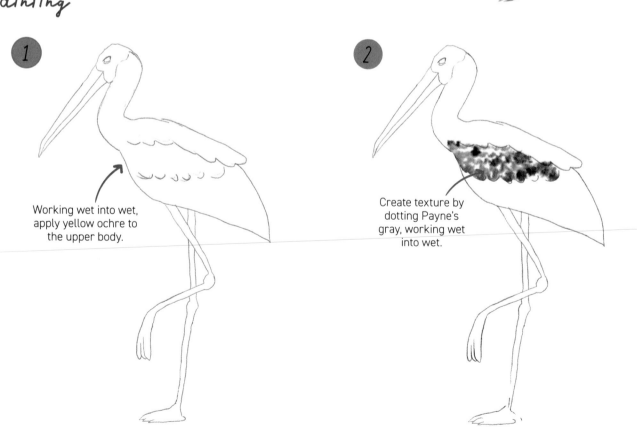

Colours

 Cadmium orange

 Cadmium yellow

 Purple lake

 Cobalt blue

 Burnt sienna

 Yellow ochre

 Payne's gray

Painting

1

Working wet into wet, apply yellow ochre to the upper body.

2

Create texture by dotting Payne's gray, working wet into wet.

56

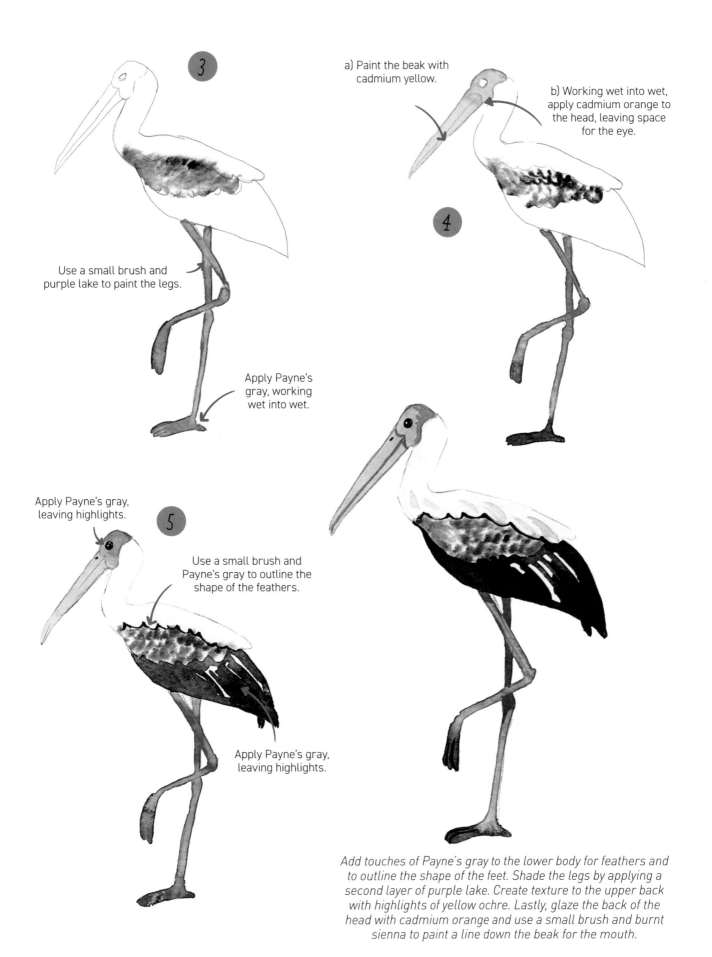

3

Use a small brush and purple lake to paint the legs.

Apply Payne's gray, working wet into wet.

a) Paint the beak with cadmium yellow.

b) Working wet into wet, apply cadmium orange to the head, leaving space for the eye.

4

Apply Payne's gray, leaving highlights.

5

Use a small brush and Payne's gray to outline the shape of the feathers.

Apply Payne's gray, leaving highlights.

Add touches of Payne's gray to the lower body for feathers and to outline the shape of the feet. Shade the legs by applying a second layer of purple lake. Create texture to the upper back with highlights of yellow ochre. Lastly, glaze the back of the head with cadmium orange and use a small brush and burnt sienna to paint a line down the beak for the mouth.

Lion

Drawing and colours

Transfer the line drawing to your watercolour paper as described on page 5.

Colours

Raw umber

Payne's gray

Burnt umber

Painting

1

a) Paint the body and the top of the head with a flat wash of raw umber.

b) Drop in water to the wet paint and let the colours bleed down.

c) Use a strong wash of Payne's gray for the mane, leaving highlights.

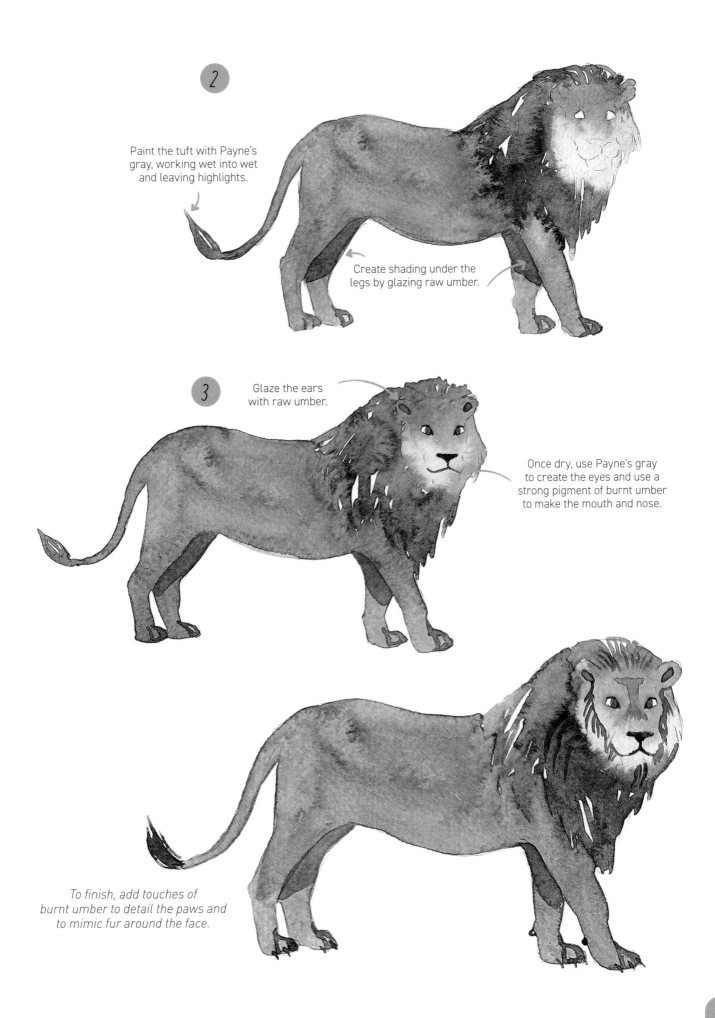

2

Paint the tuft with Payne's gray, working wet into wet and leaving highlights.

Create shading under the legs by glazing raw umber.

3

Glaze the ears with raw umber.

Once dry, use Payne's gray to create the eyes and use a strong pigment of burnt umber to make the mouth and nose.

To finish, add touches of burnt umber to detail the paws and to mimic fur around the face.

Tiger

Drawing and colours

Transfer the line drawing to your watercolour paper as described on page 5.

Colours

Cadmium red pale Payne's gray

Painting

1

Begin by applying a flat wash of cadmium red pale.

Drop in a light wash of Payne's gray, working wet into wet, to the underside of the body and the head.

2

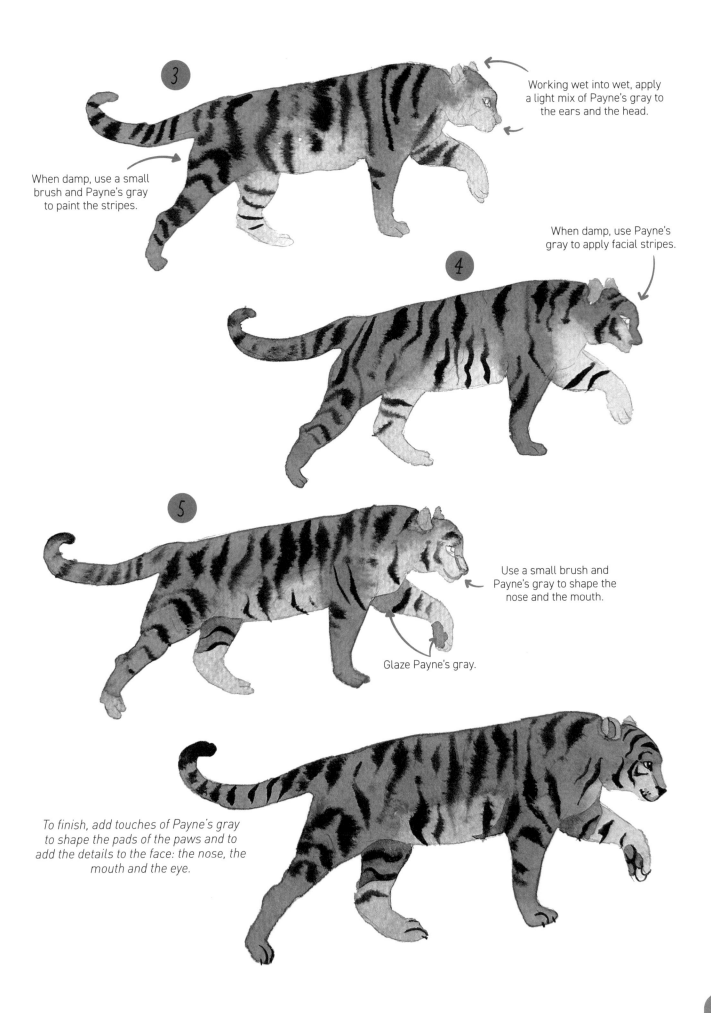

3

When damp, use a small brush and Payne's gray to paint the stripes.

Working wet into wet, apply a light mix of Payne's gray to the ears and the head.

4

When damp, use Payne's gray to apply facial stripes.

5

Use a small brush and Payne's gray to shape the nose and the mouth.

Glaze Payne's gray.

To finish, add touches of Payne's gray to shape the pads of the paws and to add the details to the face: the nose, the mouth and the eye.

Zebra

Drawing and colours

Transfer the line drawing to your watercolour paper as described on page 5.

Colours

Cobalt blue

Payne's gray

Yellow ochre

Painting

1 Begin by painting the upper body with a light wash of cobalt blue.

2 Working wet into wet, apply yellow ochre, allowing the colours to bleed together.

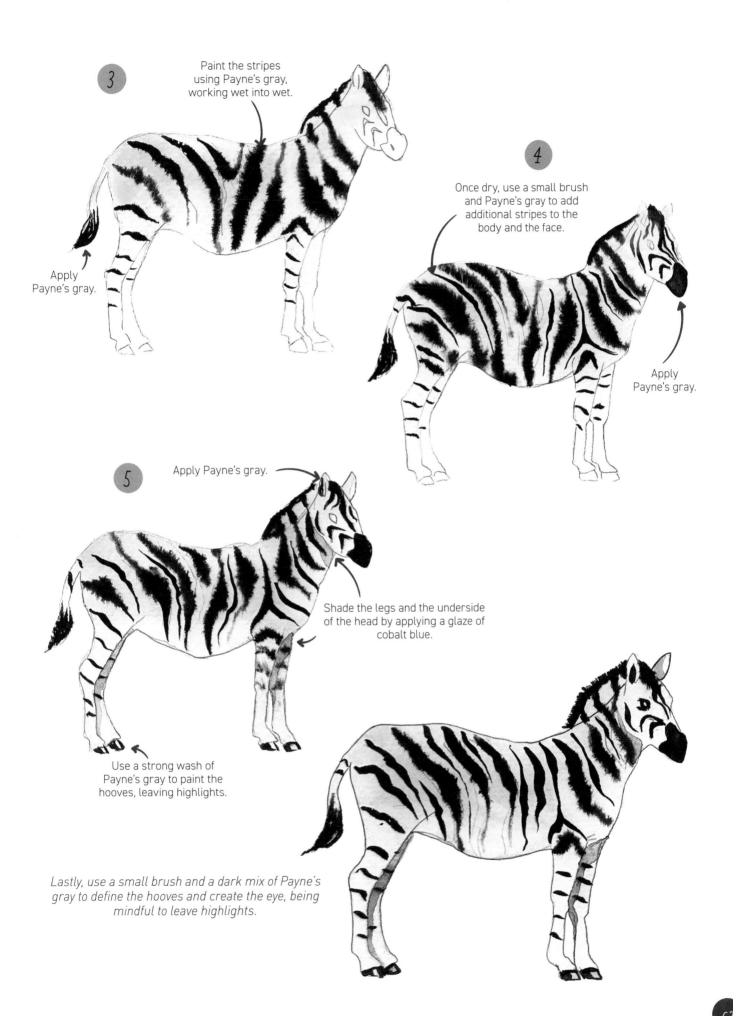

3

Paint the stripes using Payne's gray, working wet into wet.

Apply Payne's gray.

4

Once dry, use a small brush and Payne's gray to add additional stripes to the body and the face.

Apply Payne's gray.

5

Apply Payne's gray.

Shade the legs and the underside of the head by applying a glaze of cobalt blue.

Use a strong wash of Payne's gray to paint the hooves, leaving highlights.

Lastly, use a small brush and a dark mix of Payne's gray to define the hooves and create the eye, being mindful to leave highlights.

Hamster

Drawing and colours

Transfer the line drawing to your watercolour paper as described on page 5.

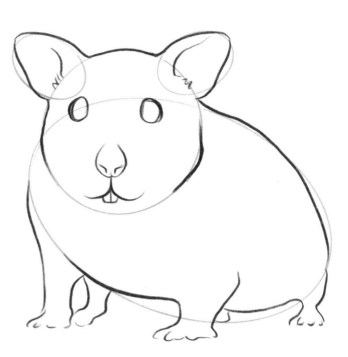

Colours

 Cadmium orange

 Cadmium red deep

 Payne's gray

Painting

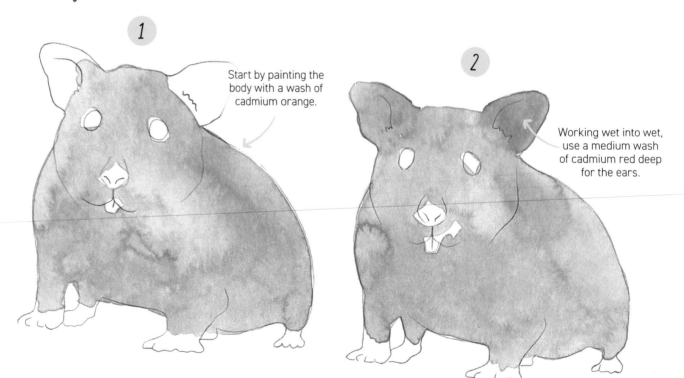

1

Start by painting the body with a wash of cadmium orange.

2

Working wet into wet, use a medium wash of cadmium red deep for the ears.

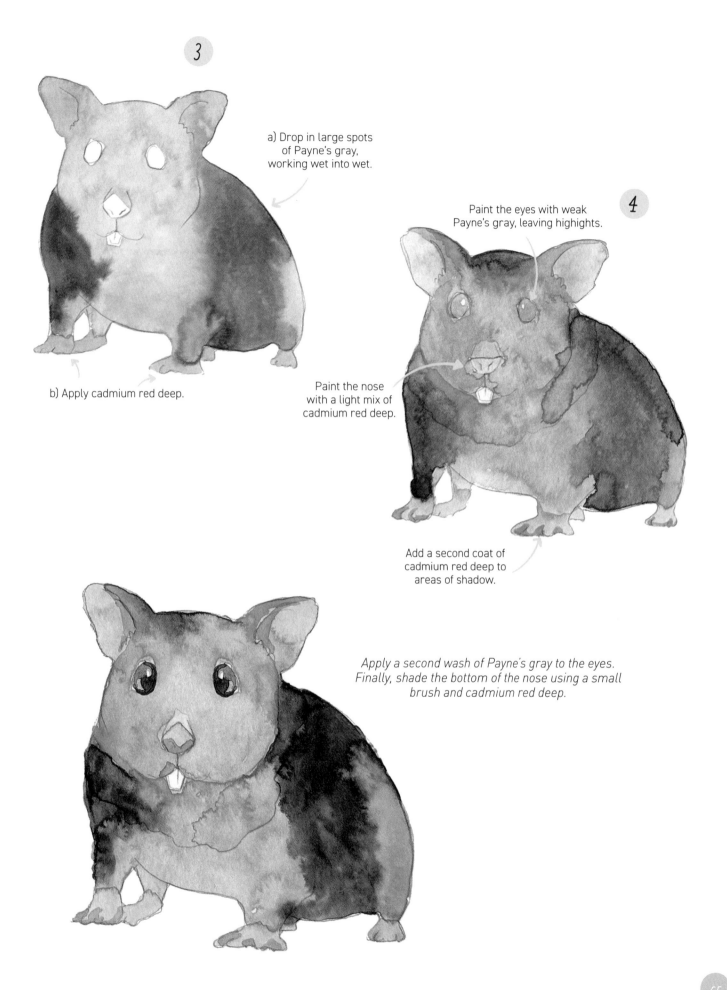

3

a) Drop in large spots of Payne's gray, working wet into wet.

b) Apply cadmium red deep.

4

Paint the eyes with weak Payne's gray, leaving highights.

Paint the nose with a light mix of cadmium red deep.

Add a second coat of cadmium red deep to areas of shadow.

Apply a second wash of Payne's gray to the eyes. Finally, shade the bottom of the nose using a small brush and cadmium red deep.

Squirrel

Drawing and colours

Transfer the line drawing to your watercolour paper as described on page 5.

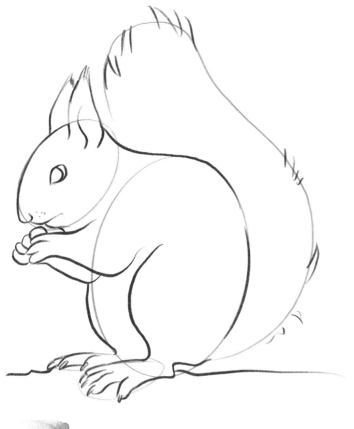

Colours

 Burnt sienna

 Payne's gray

 Burnt umber

Cadmium red deep

Yellow ochre

Sap green

Painting

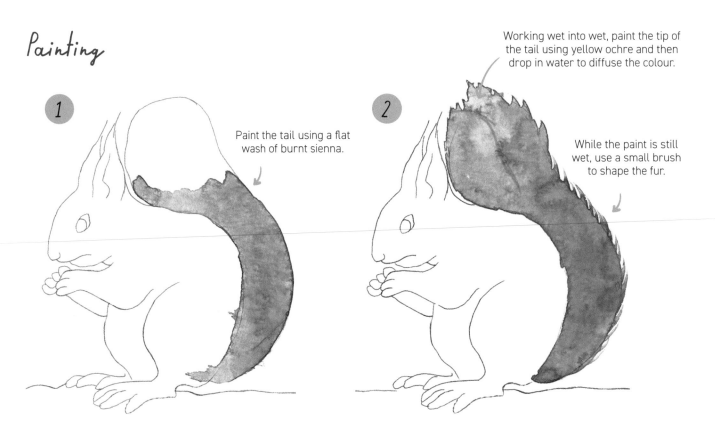

1 Paint the tail using a flat wash of burnt sienna.

2 Working wet into wet, paint the tip of the tail using yellow ochre and then drop in water to diffuse the colour.

While the paint is still wet, use a small brush to shape the fur.

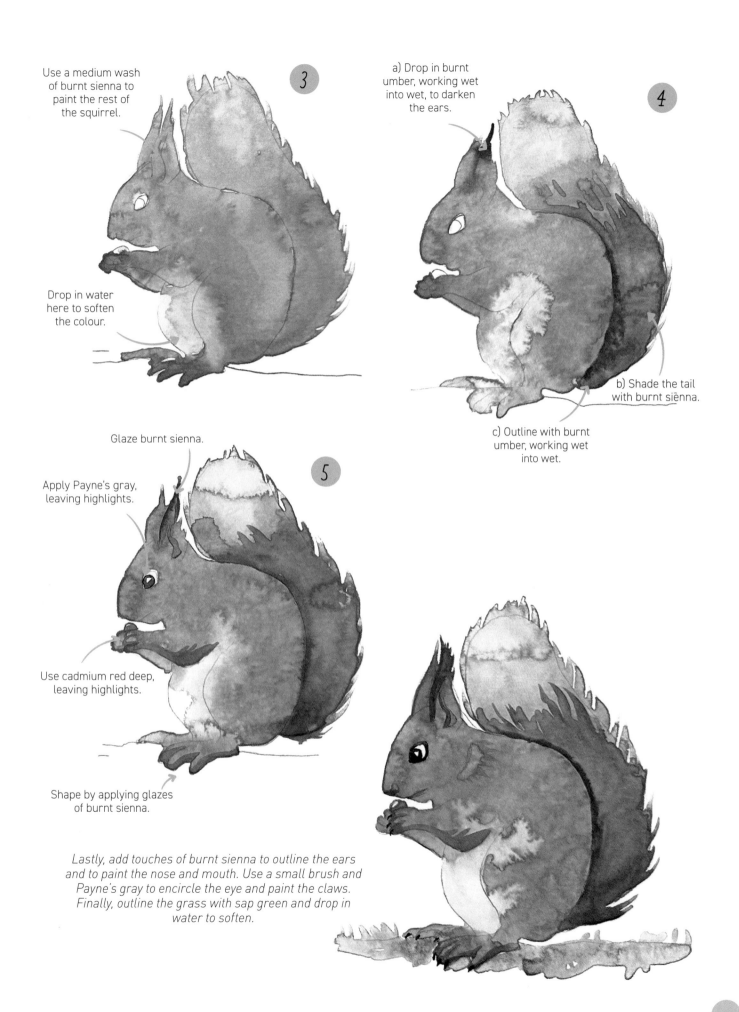

Use a medium wash of burnt sienna to paint the rest of the squirrel.

3

Drop in water here to soften the colour.

a) Drop in burnt umber, working wet into wet, to darken the ears.

4

b) Shade the tail with burnt siènna.

c) Outline with burnt umber, working wet into wet.

Glaze burnt sienna.

Apply Payne's gray, leaving highlights.

5

Use cadmium red deep, leaving highlights.

Shape by applying glazes of burnt sienna.

Lastly, add touches of burnt sienna to outline the ears and to paint the nose and mouth. Use a small brush and Payne's gray to encircle the eye and paint the claws. Finally, outline the grass with sap green and drop in water to soften.

Toucan

Drawing and colours

Transfer the line drawing to your watercolour paper as described on page 5. This painting requires you to mix cadmium yellow pale together with emerald to create a new colour.

Colours

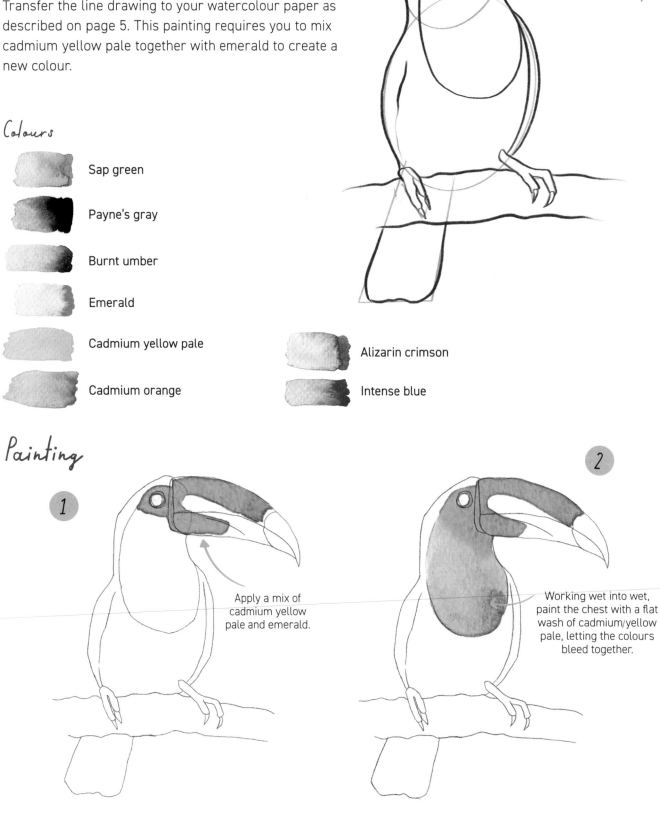

Sap green

Payne's gray

Burnt umber

Emerald

Cadmium yellow pale

Cadmium orange

Alizarin crimson

Intense blue

Painting

1

Apply a mix of cadmium yellow pale and emerald.

2

Working wet into wet, paint the chest with a flat wash of cadmium/yellow pale, letting the colours bleed together.

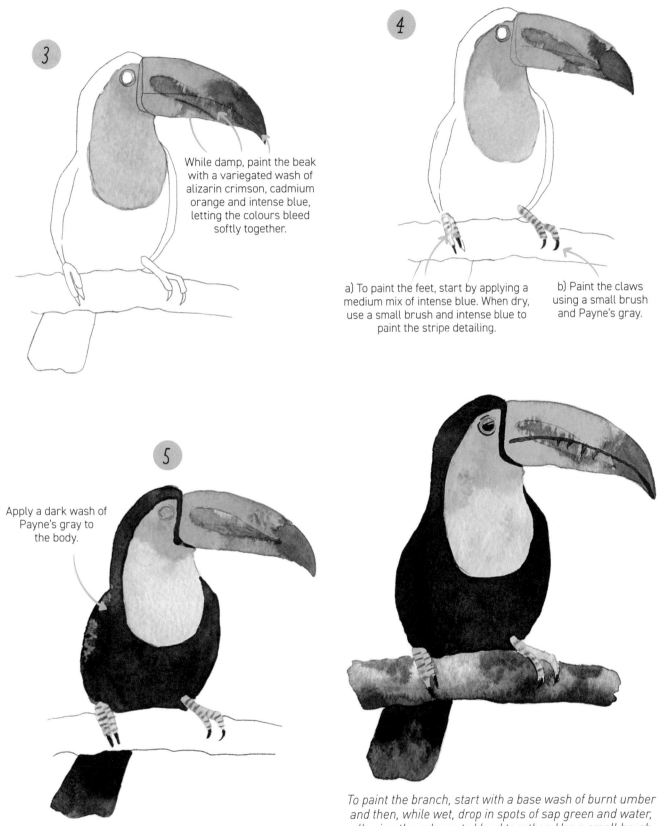

3

While damp, paint the beak with a variegated wash of alizarin crimson, cadmium orange and intense blue, letting the colours bleed softly together.

4

a) To paint the feet, start by applying a medium mix of intense blue. When dry, use a small brush and intense blue to paint the stripe detailing.

b) Paint the claws using a small brush and Payne's gray.

5

Apply a dark wash of Payne's gray to the body.

To paint the branch, start with a base wash of burnt umber and then, while wet, drop in spots of sap green and water, allowing the colours to bleed together. Use a small brush and alizarin crimson to paint the mouth. Finally, use Payne's gray to paint the eye.

Gopher

Drawing and colours

Transfer the line drawing to your watercolour paper as described on page 5.

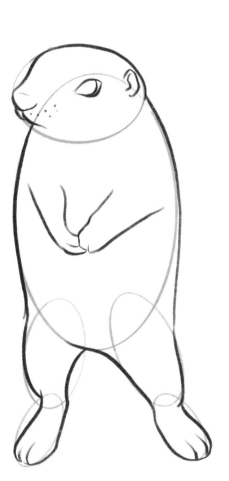

Colours

 Raw umber

 Burnt sienna

 Burnt umber

Painting

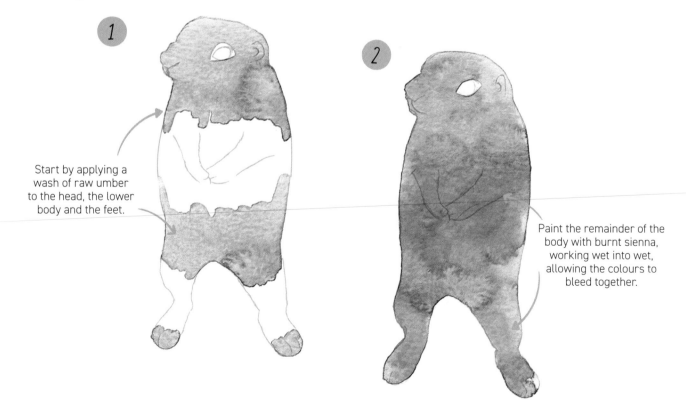

1

Start by applying a wash of raw umber to the head, the lower body and the feet.

2

Paint the remainder of the body with burnt sienna, working wet into wet, allowing the colours to bleed together.

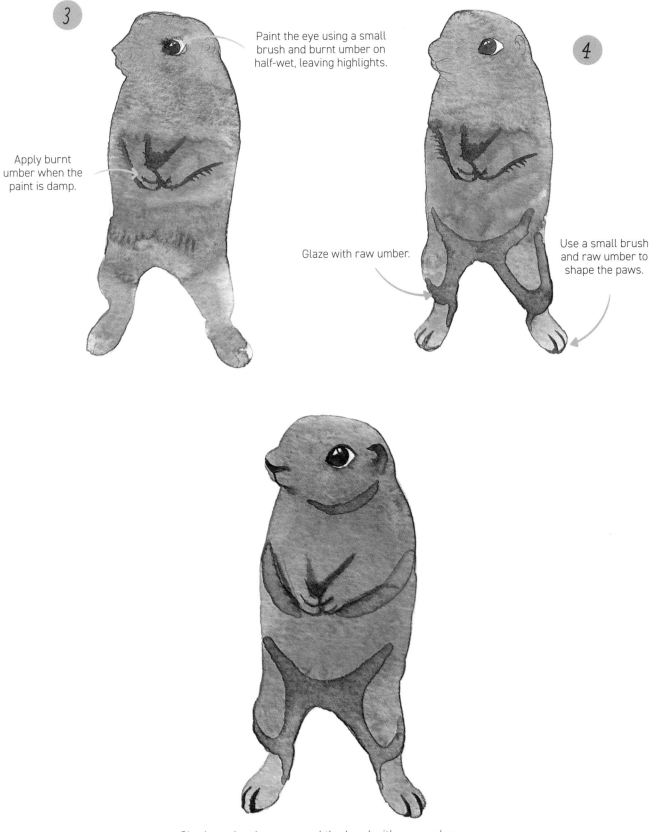

3

Paint the eye using a small brush and burnt umber on half-wet, leaving highlights.

Apply burnt umber when the paint is damp.

4

Glaze with raw umber.

Use a small brush and raw umber to shape the paws.

Shade under the arms and the head with raw umber.
Add a second glaze of burnt umber to the eye. Finally,
use burnt umber to add the nose and the ear.

Elephant

Drawing and colours

Transfer the line drawing to your watercolour paper as described on page 5.

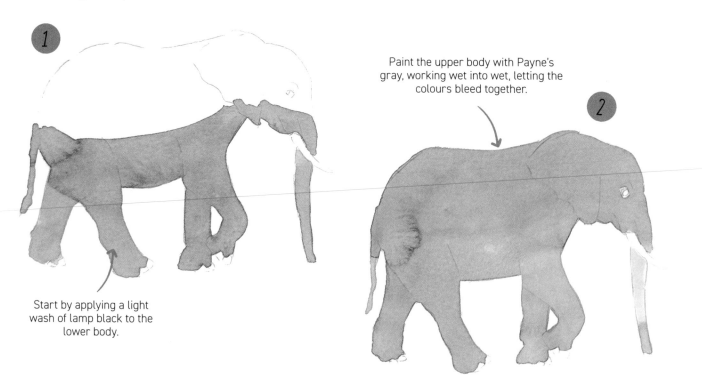

Colours

 Yellow ochre

 Payne's gray

 Lamp black

Painting

1

2

Paint the upper body with Payne's gray, working wet into wet, letting the colours bleed together.

Start by applying a light wash of lamp black to the lower body.

72

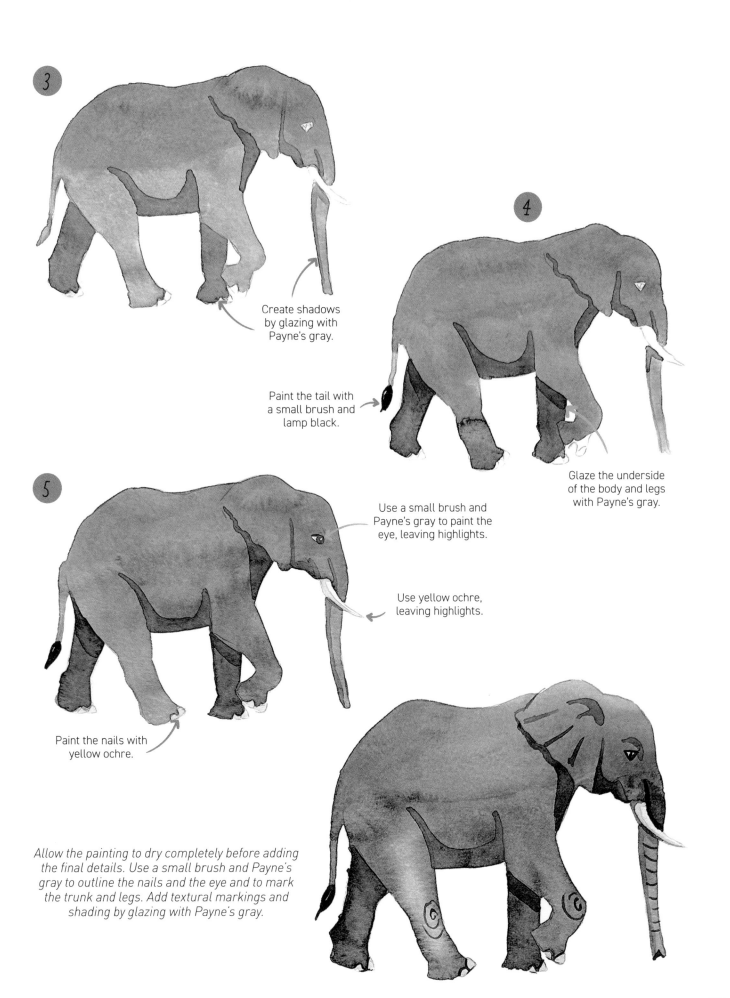

3

Create shadows by glazing with Payne's gray.

Paint the tail with a small brush and lamp black.

4

Glaze the underside of the body and legs with Payne's gray.

5

Use a small brush and Payne's gray to paint the eye, leaving highlights.

Use yellow ochre, leaving highlights.

Paint the nails with yellow ochre.

Allow the painting to dry completely before adding the final details. Use a small brush and Payne's gray to outline the nails and the eye and to mark the trunk and legs. Add textural markings and shading by glazing with Payne's gray.

Monkey

Drawing and colours

Transfer the line drawing to your watercolour paper as described on page 5.

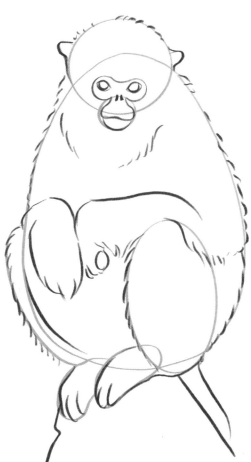

Colours

 Burnt sienna

 Payne's gray

 Burnt umber

Painting

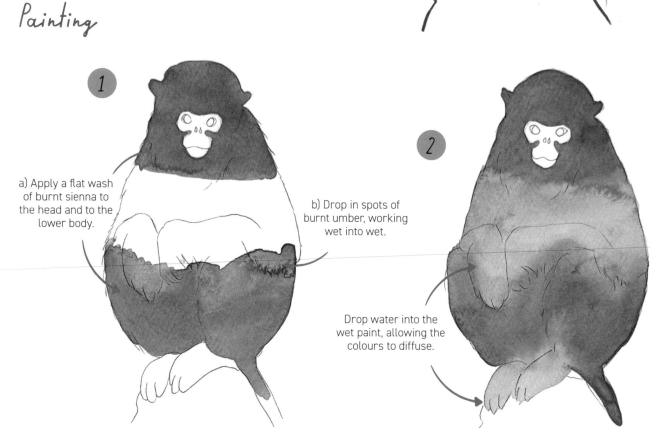

1

a) Apply a flat wash of burnt sienna to the head and to the lower body.

b) Drop in spots of burnt umber, working wet into wet.

2

Drop water into the wet paint, allowing the colours to diffuse.

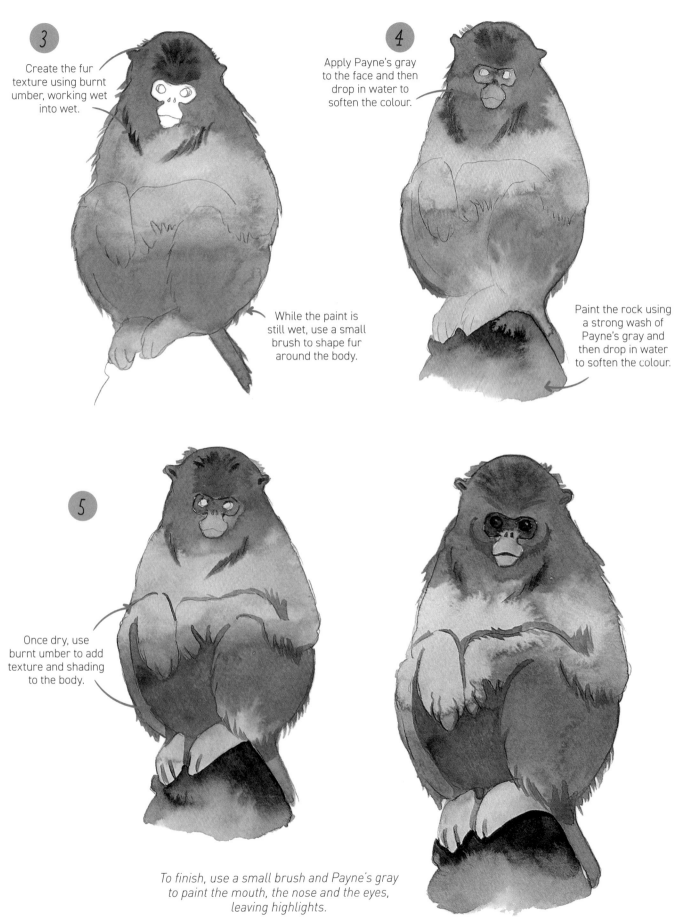

3

Create the fur texture using burnt umber, working wet into wet.

While the paint is still wet, use a small brush to shape fur around the body.

4

Apply Payne's gray to the face and then drop in water to soften the colour.

Paint the rock using a strong wash of Payne's gray and then drop in water to soften the colour.

5

Once dry, use burnt umber to add texture and shading to the body.

To finish, use a small brush and Payne's gray to paint the mouth, the nose and the eyes, leaving highlights.

Pig

Drawing and colours

Transfer the line drawing to your watercolour paper as described on page 5.

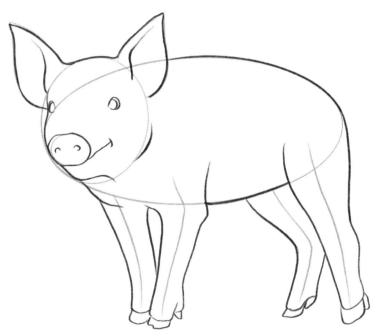

Colours

Alizarin crimson

Burnt sienna

Payne's gray

Burnt umber

Painting

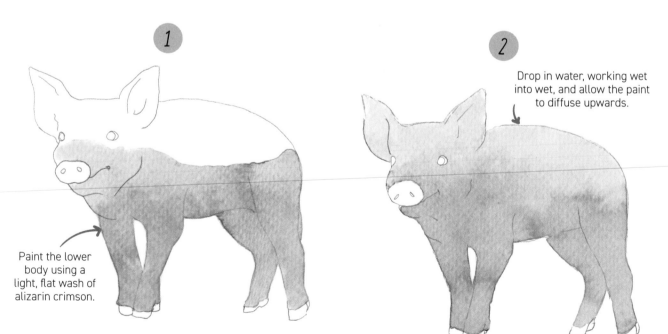

1

Paint the lower body using a light, flat wash of alizarin crimson.

2

Drop in water, working wet into wet, and allow the paint to diffuse upwards.

Working wet into wet,
drop in alizarin crimson to
shade the ears.

3

Apply burnt sienna,
working wet into wet.

4

Glaze a dark mix of
alizarin crimson to
darken the inner ears.

Shade the
underside of
the body with a
second layer of
alizarin crimson.

Paint the hooves using
burnt umber.

*Outline the hooves with a glaze of burnt umber.
To paint the nose, apply a dark wash of alizarin
crimson before dropping in water to diffuse the
colour. Finally, use a small brush and Payne's gray
to paint the eyes, leaving highlights.*

Wolf

Drawing and colours

Transfer the line drawing to your watercolour paper as described on page 5.

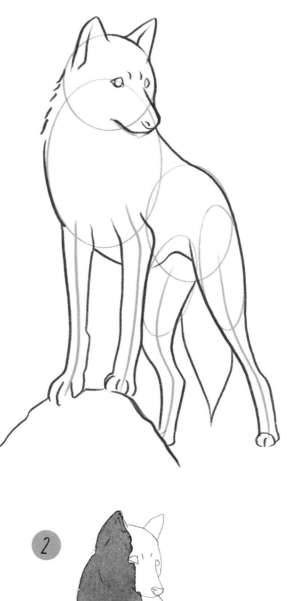

Colours

 Raw umber

Sap green

 Payne's gray

 Lamp black

Painting

1

Start with a medium wash of Payne's gray.

2

Apply raw umber, working wet into wet.

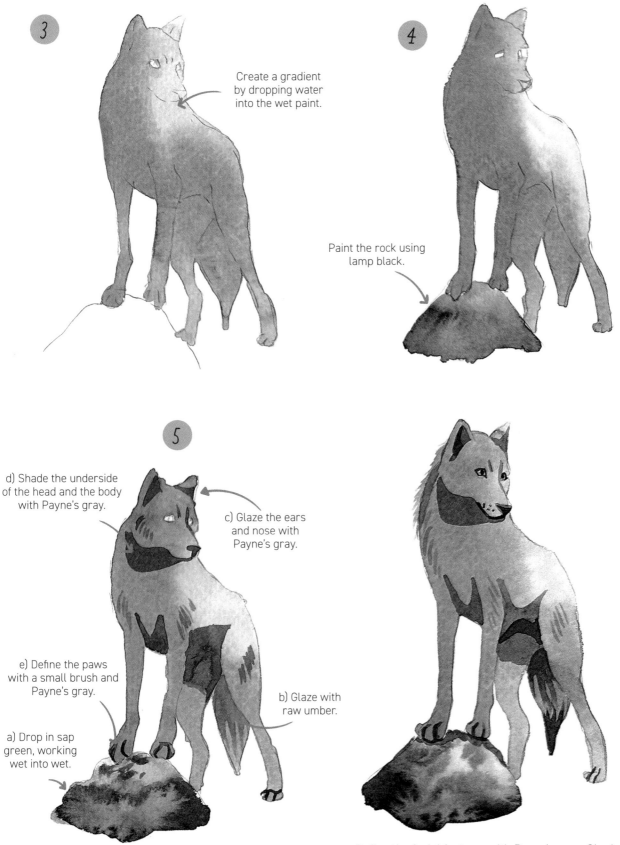

3

Create a gradient by dropping water into the wet paint.

4

Paint the rock using lamp black.

5

d) Shade the underside of the head and the body with Payne's gray.

c) Glaze the ears and nose with Payne's gray.

e) Define the paws with a small brush and Payne's gray.

b) Glaze with raw umber.

a) Drop in sap green, working wet into wet.

Define the facial features with Payne's gray. Shade the underside of the body and the top of the rock with a secondary glaze of Payne's gray. Finally, paint the tip of the tail with Payne's gray.

Skunk

Drawing and colours

Transfer the line drawing to your watercolour paper as described on page 5.

Colours

 Payne's gray

Painting

1

Apply a strong wash of Payne's gray to the upper back and lower tail.

2

Create a gradient by dropping water into wet at the end of the tail.

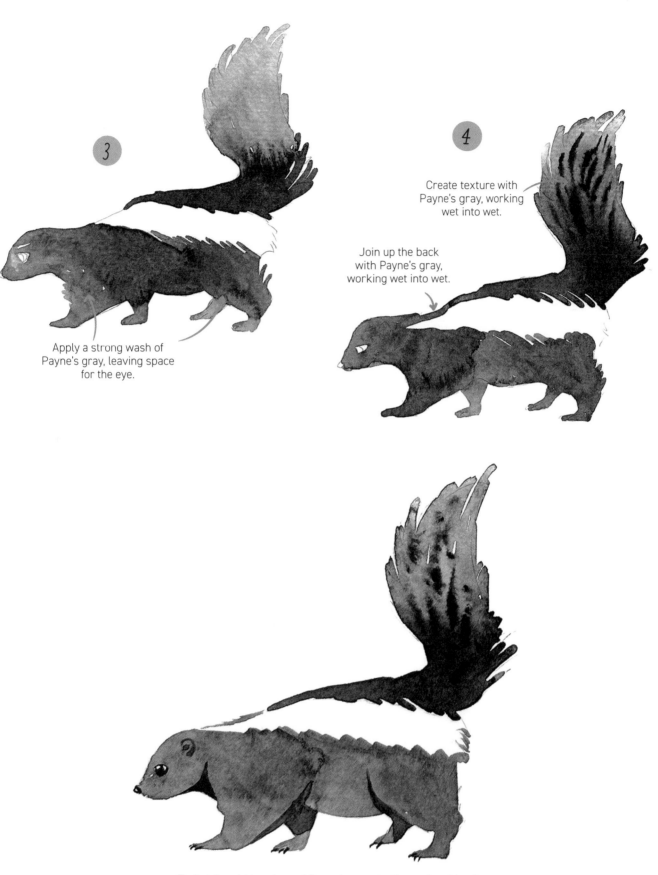

3 Apply a strong wash of Payne's gray, leaving space for the eye.

4 Create texture with Payne's gray, working wet into wet.

Join up the back with Payne's gray, working wet into wet.

To finish, add touches of Payne's gray to the underside of the body and legs to create shading and, using a small brush, paint the eye.

Swan

Drawing and colours

Transfer the line drawing to your watercolour paper as described on page 5.

Colours

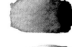 Lamp black

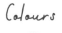 Cobalt blue

Yellow ochre

Purple lake

Cadmium red pale

Painting

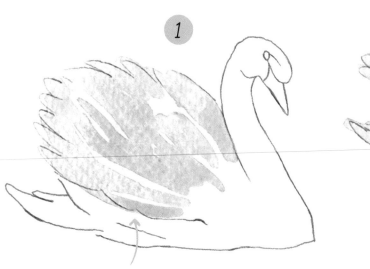

1 Begin with a light wash of cobalt blue, leaving highlights.

2 Working wet into wet, paint the lower body with a light wash of purple lake, letting the colours bleed together.

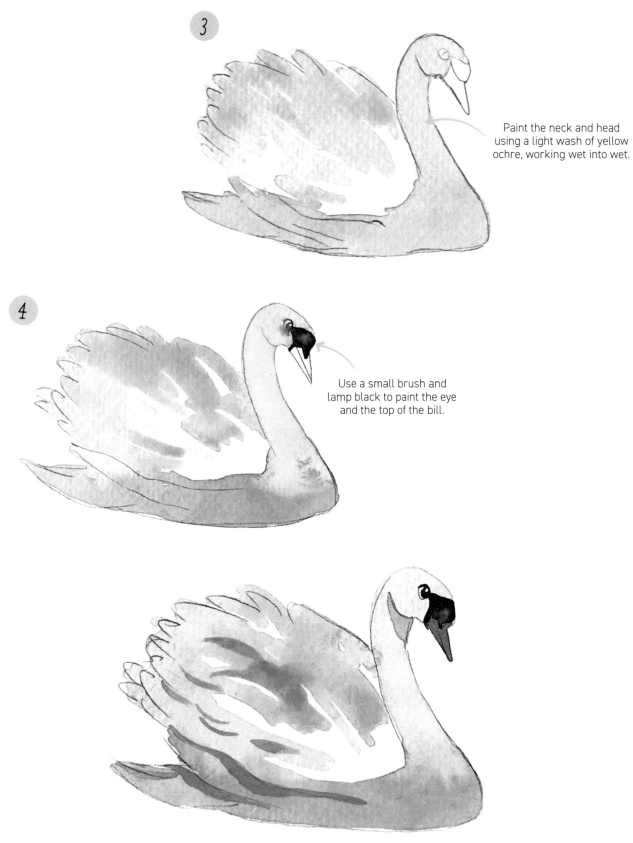

3

Paint the neck and head using a light wash of yellow ochre, working wet into wet.

4

Use a small brush and lamp black to paint the eye and the top of the bill.

Lastly, use a flat mix of cadmium red pale to paint the bill. Glaze under the head and the lower body using purple lake to create shading.

Rabbit

Drawing and colours

Transfer the line drawing to your watercolour paper as described on page 5.

Colours

Alizarin crimson

Yellow ochre

Payne's gray

Burnt umber

Burnt sienna

Painting

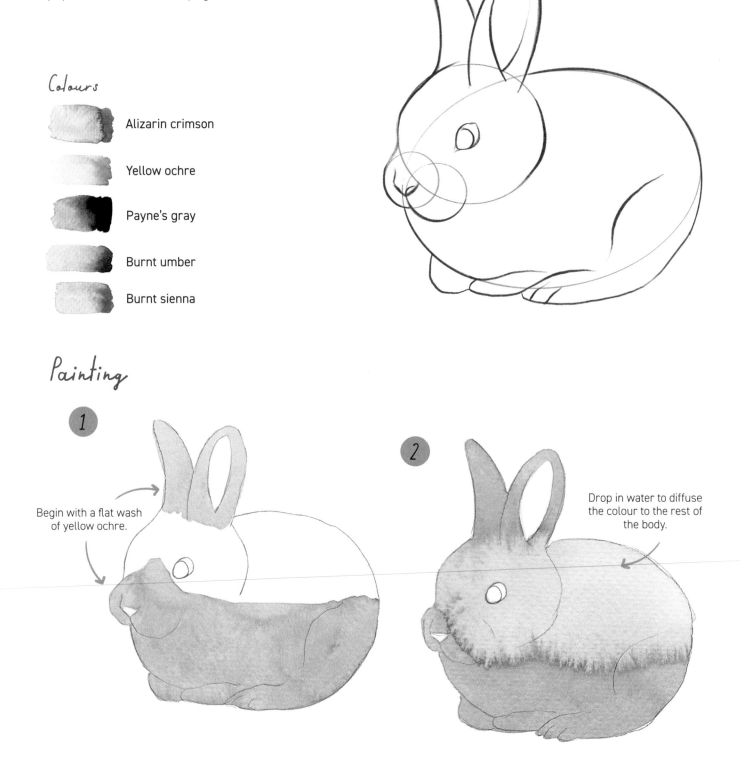

1

Begin with a flat wash of yellow ochre.

2

Drop in water to diffuse the colour to the rest of the body.

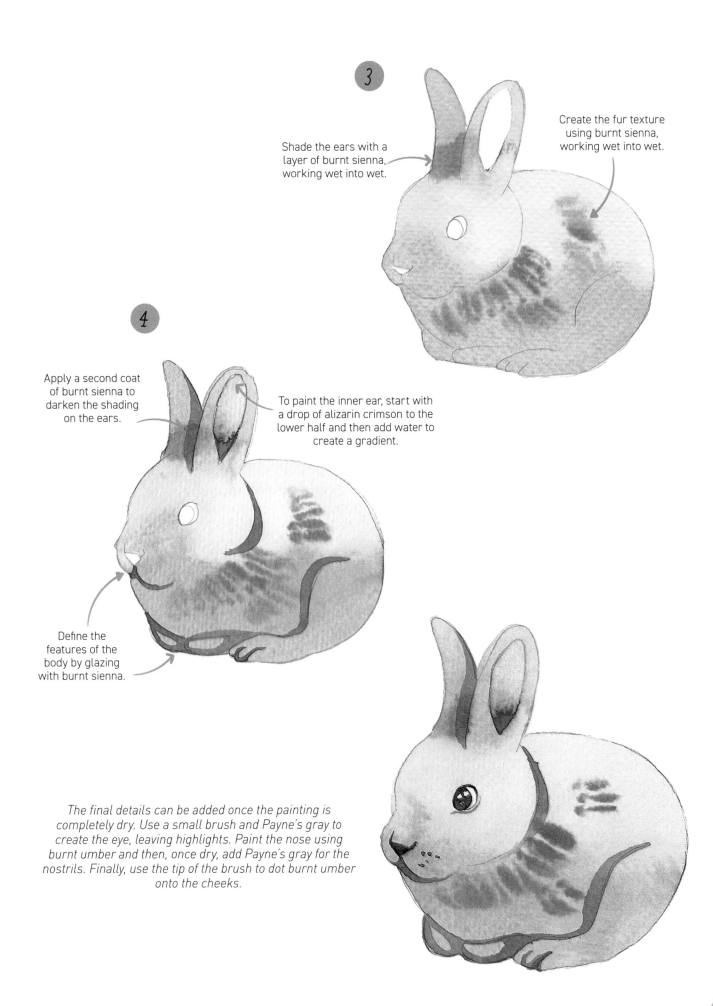

3

Shade the ears with a layer of burnt sienna, working wet into wet.

Create the fur texture using burnt sienna, working wet into wet.

4

Apply a second coat of burnt sienna to darken the shading on the ears.

To paint the inner ear, start with a drop of alizarin crimson to the lower half and then add water to create a gradient.

Define the features of the body by glazing with burnt sienna.

The final details can be added once the painting is completely dry. Use a small brush and Payne's gray to create the eye, leaving highlights. Paint the nose using burnt umber and then, once dry, add Payne's gray for the nostrils. Finally, use the tip of the brush to dot burnt umber onto the cheeks.

Flamingo

Drawing and colours

Transfer the line drawing to your watercolour paper as described on page 5.

Colours

 Cadmium red pale

 Cadmium red deep

 Alizarin crimson

 Purple lake

 Payne's gray

Painting

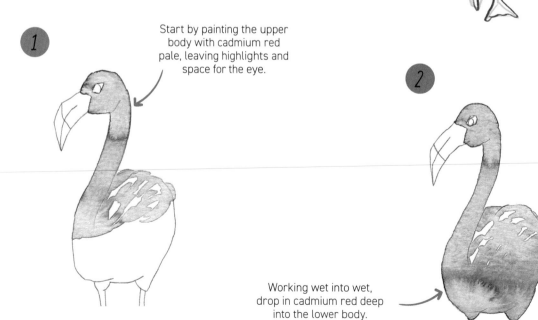

1 Start by painting the upper body with cadmium red pale, leaving highlights and space for the eye.

2 Working wet into wet, drop in cadmium red deep into the lower body.

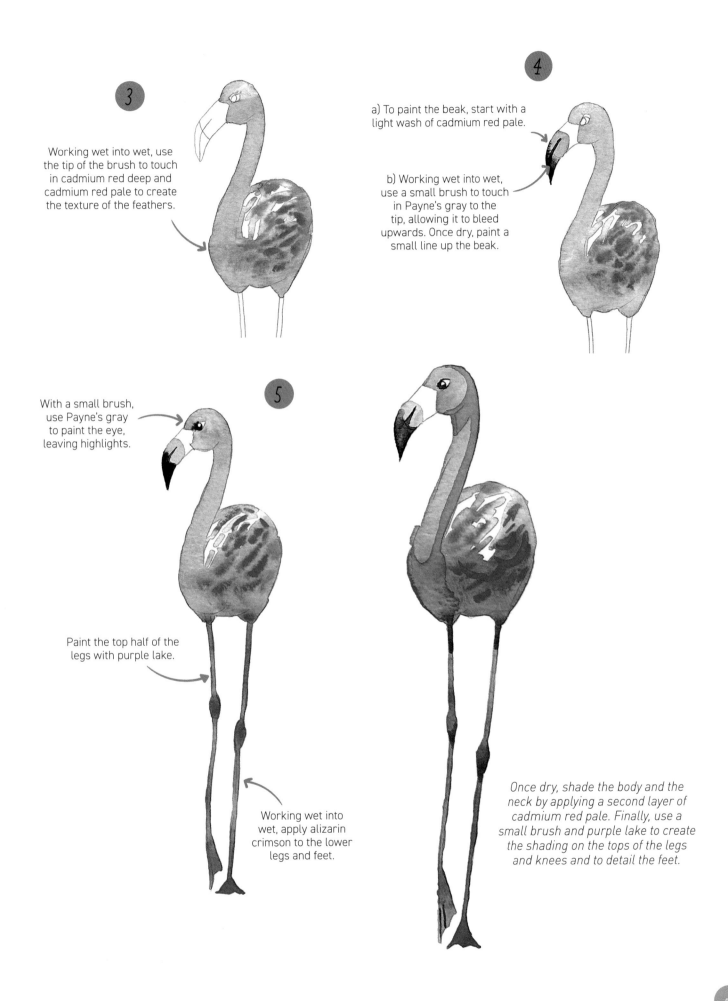

3

Working wet into wet, use the tip of the brush to touch in cadmium red deep and cadmium red pale to create the texture of the feathers.

4

a) To paint the beak, start with a light wash of cadmium red pale.

b) Working wet into wet, use a small brush to touch in Payne's gray to the tip, allowing it to bleed upwards. Once dry, paint a small line up the beak.

5

With a small brush, use Payne's gray to paint the eye, leaving highlights.

Paint the top half of the legs with purple lake.

Working wet into wet, apply alizarin crimson to the lower legs and feet.

Once dry, shade the body and the neck by applying a second layer of cadmium red pale. Finally, use a small brush and purple lake to create the shading on the tops of the legs and knees and to detail the feet.

Fox

Drawing and colours

Transfer the line drawing to your watercolour paper as described on page 5.

Colours

 Cadmium red pale

Payne's gray

Painting

Start with a
strong flat wash of
cadmium red pale.

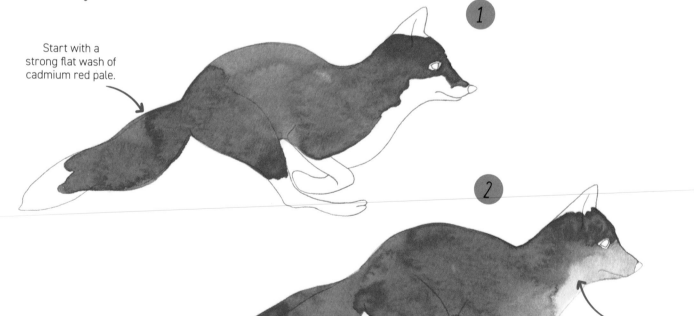

While wet, drop in
water to create a
soft gradient.

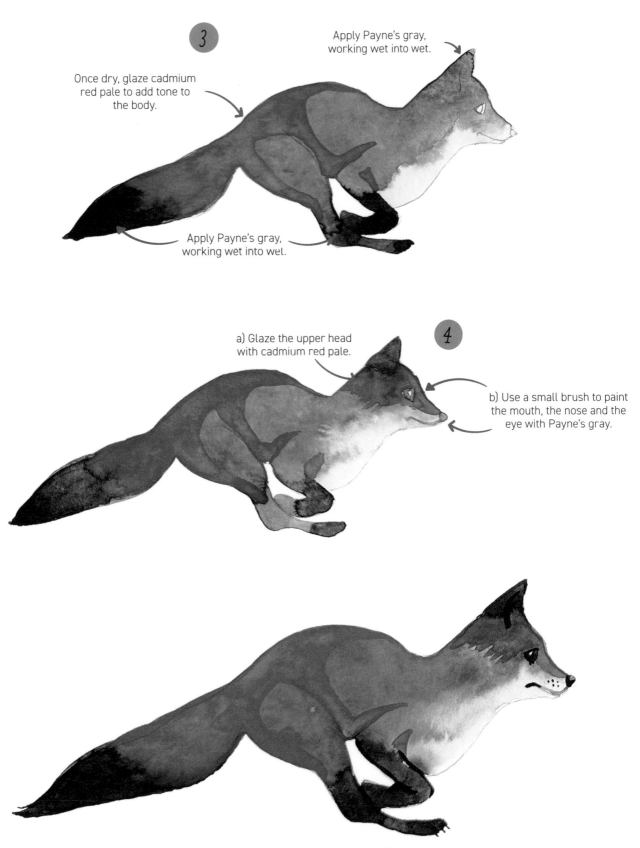

3

Once dry, glaze cadmium red pale to add tone to the body.

Apply Payne's gray, working wet into wet.

Apply Payne's gray, working wet into wel.

4

a) Glaze the upper head with cadmium red pale.

b) Use a small brush to paint the mouth, the nose and the eye with Payne's gray.

Once completely dry, use a small brush and Payne's gray to define the facial features and to paint the claws.

Rhinoceros

Drawing and colours

Transfer the line drawing to your watercolour paper as described on page 5.

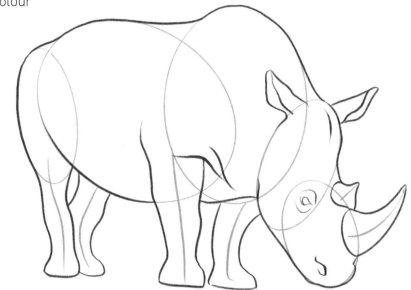

Colours

Raw umber

Yellow ochre

Payne's gray

Painting

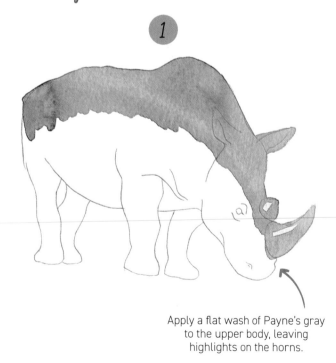

1

Apply a flat wash of Payne's gray to the upper body, leaving highlights on the horns.

2

b) While the previous stage is still wet, apply drops of yellow ochre to the upper body.

a) Working wet into wet, paint the mid-section with raw umber and the lower body with yellow ochre, allowing the colours to bleed softly together.

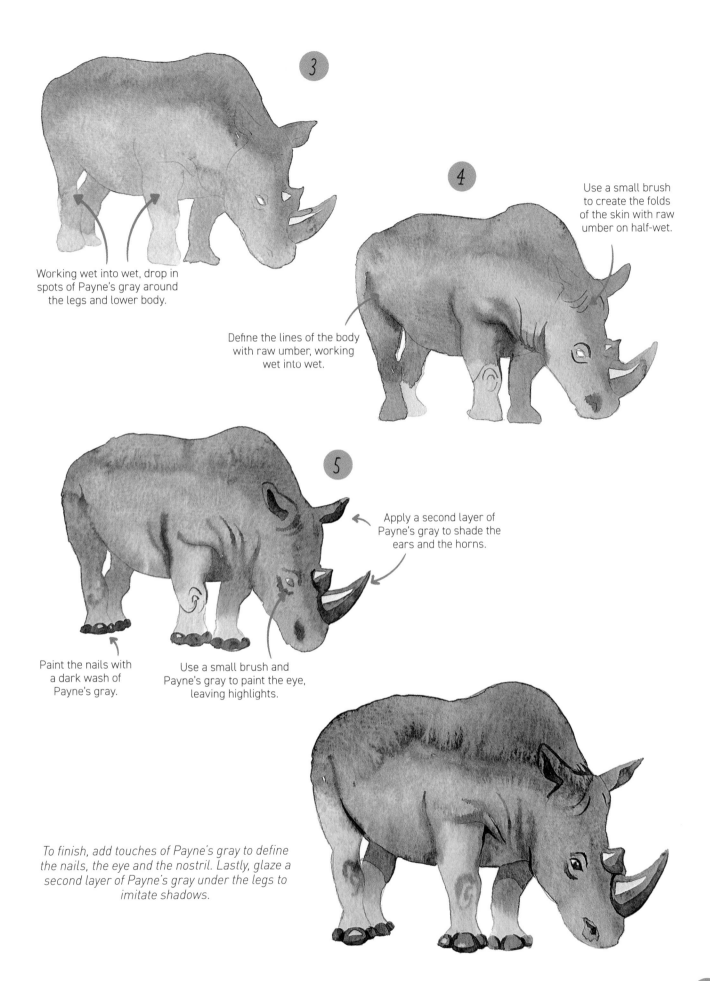

3

Working wet into wet, drop in spots of Payne's gray around the legs and lower body.

4

Use a small brush to create the folds of the skin with raw umber on half-wet.

Define the lines of the body with raw umber, working wet into wet.

5

Apply a second layer of Payne's gray to shade the ears and the horns.

Paint the nails with a dark wash of Payne's gray.

Use a small brush and Payne's gray to paint the eye, leaving highlights.

To finish, add touches of Payne's gray to define the nails, the eye and the nostril. Lastly, glaze a second layer of Payne's gray under the legs to imitate shadows.

Crocodile

Drawing and colours

Transfer the line drawing to your watercolour paper as described on page 5.

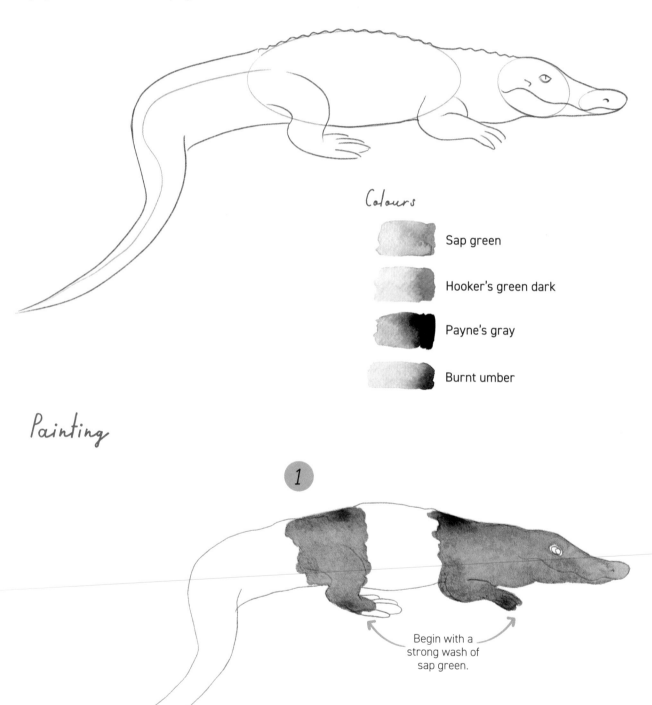

Colours

Sap green

Hooker's green dark

Payne's gray

Burnt umber

Painting

1

Begin with a strong wash of sap green.

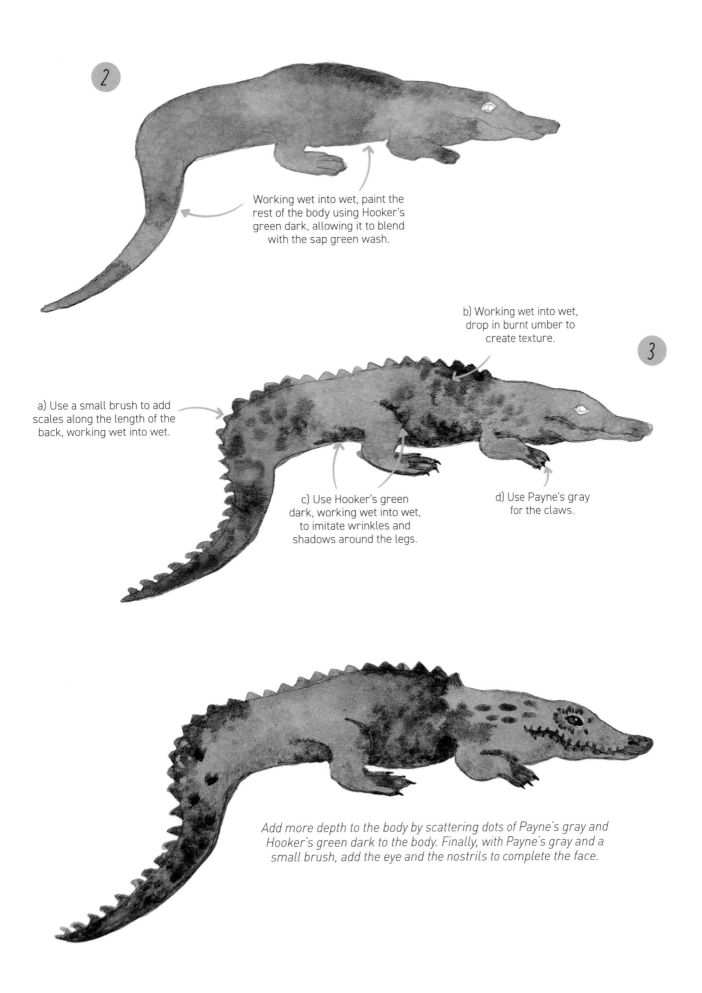

2

Working wet into wet, paint the rest of the body using Hooker's green dark, allowing it to blend with the sap green wash.

b) Working wet into wet, drop in burnt umber to create texture.

3

a) Use a small brush to add scales along the length of the back, working wet into wet.

c) Use Hooker's green dark, working wet into wet, to imitate wrinkles and shadows around the legs.

d) Use Payne's gray for the claws.

Add more depth to the body by scattering dots of Payne's gray and Hooker's green dark to the body. Finally, with Payne's gray and a small brush, add the eye and the nostrils to complete the face.

Pufferfish

Drawing and colours

Transfer the line drawing to your watercolour paper as described on page 5.

Colours

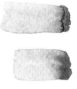 Raw umber

 Burnt sienna

Payne's gray

Burnt umber

Painting

Start by applying a strong wash of burnt sienna, leaving space for the eyes.

1

a) Start this step by outlining the fins with raw umber, working wet into wet.

2

b) Drop in water, letting the colour diffuse down the body.

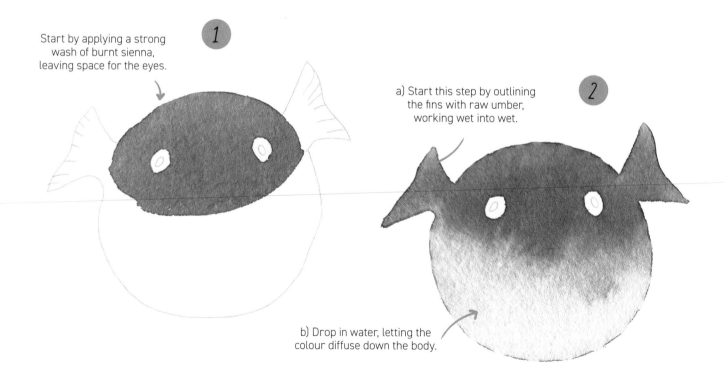

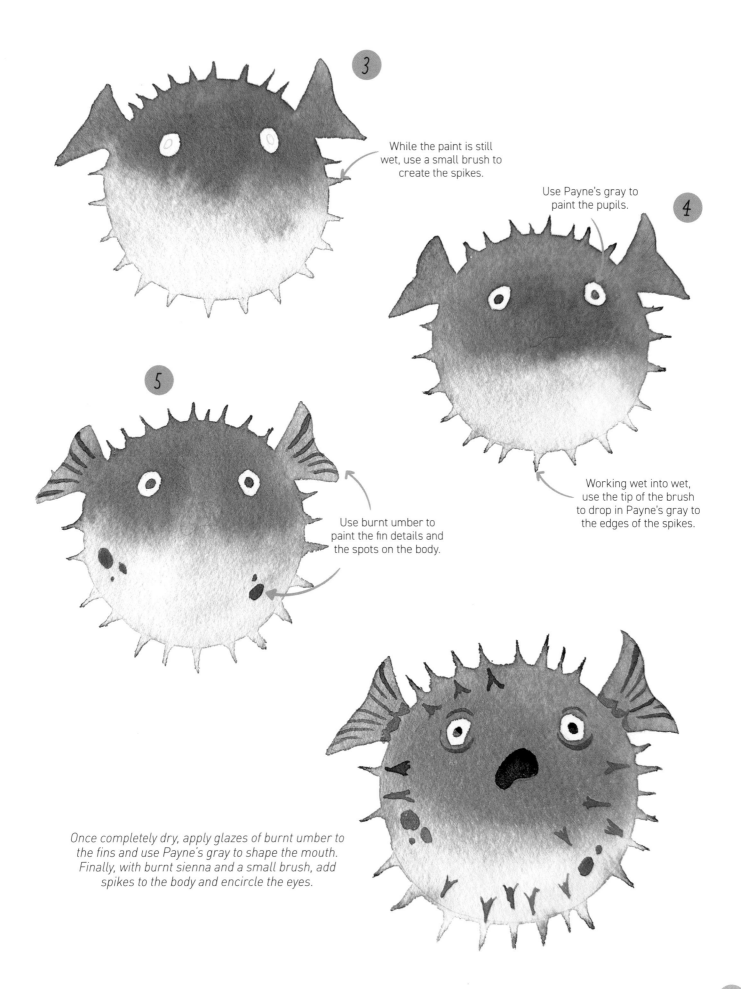

3

While the paint is still wet, use a small brush to create the spikes.

4

Use Payne's gray to paint the pupils.

Working wet into wet, use the tip of the brush to drop in Payne's gray to the edges of the spikes.

5

Use burnt umber to paint the fin details and the spots on the body.

Once completely dry, apply glazes of burnt umber to the fins and use Payne's gray to shape the mouth. Finally, with burnt sienna and a small brush, add spikes to the body and encircle the eyes.

Peacock

Drawing and colours

Transfer the line drawing to your watercolour paper as described on page 5. This painting requires masking fluid and a green watercolour pencil; I have used a Derwent watercolour pencil in the shade green grass.

Colours

Cobalt blue

Payne's gray

Emerald

Viridian

Intense blue

Painting

1 Apply drops of masking fluid to the feathers and allow to dry before applying paint.

2 b) Drop in water to soften the edges.

a) Paint the base of the fan with viridian.

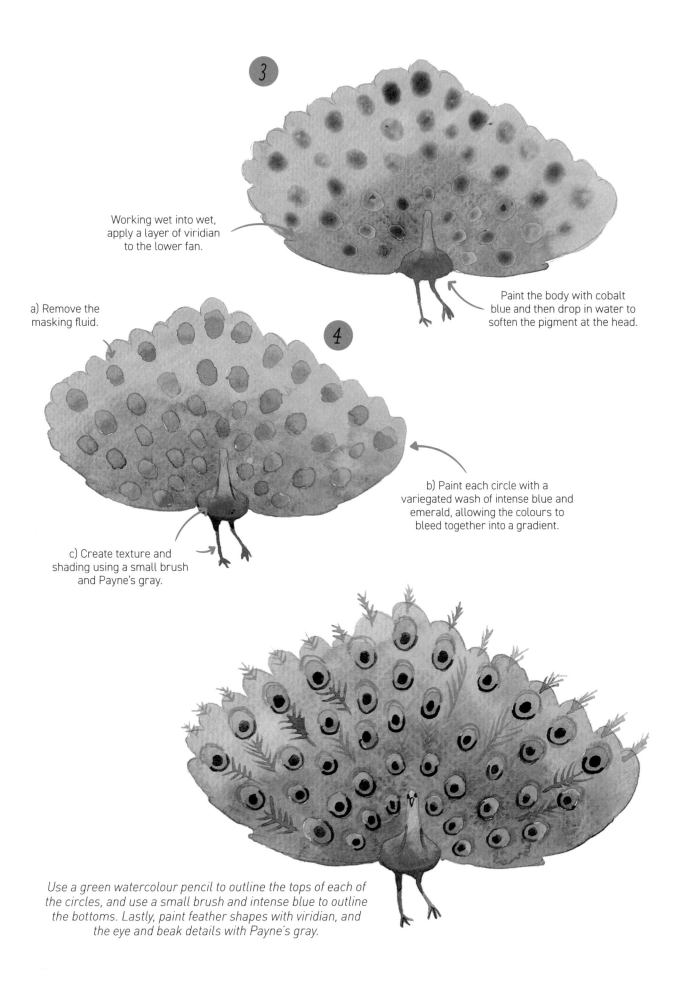

3

Working wet into wet, apply a layer of viridian to the lower fan.

Paint the body with cobalt blue and then drop in water to soften the pigment at the head.

a) Remove the masking fluid.

4

b) Paint each circle with a variegated wash of intense blue and emerald, allowing the colours to bleed together into a gradient.

c) Create texture and shading using a small brush and Payne's gray.

Use a green watercolour pencil to outline the tops of each of the circles, and use a small brush and intense blue to outline the bottoms. Lastly, paint feather shapes with viridian, and the eye and beak details with Payne's gray.

Lemur

Drawing and colours

Transfer the line drawing to your watercolour paper as described on page 5.

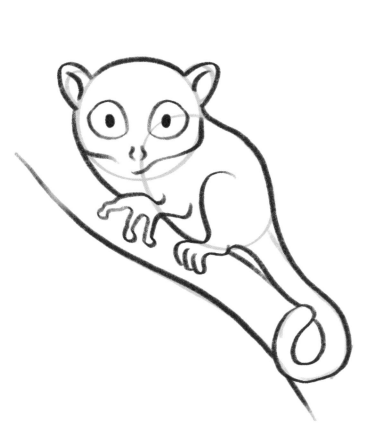

Colours

Indian red

Payne's gray

Burnt umber

Cadmium yellow

Cadmium orange

Painting

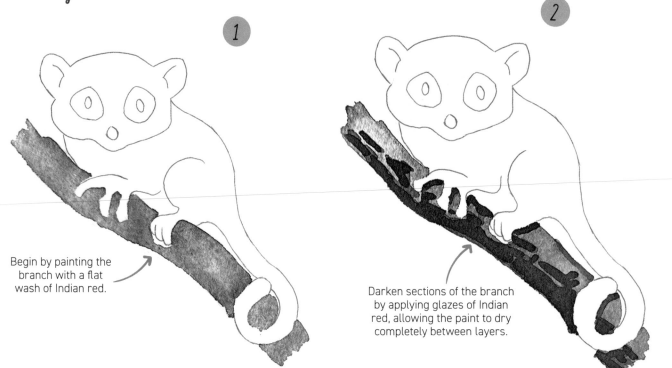

1

Begin by painting the branch with a flat wash of Indian red.

2

Darken sections of the branch by applying glazes of Indian red, allowing the paint to dry completely between layers.

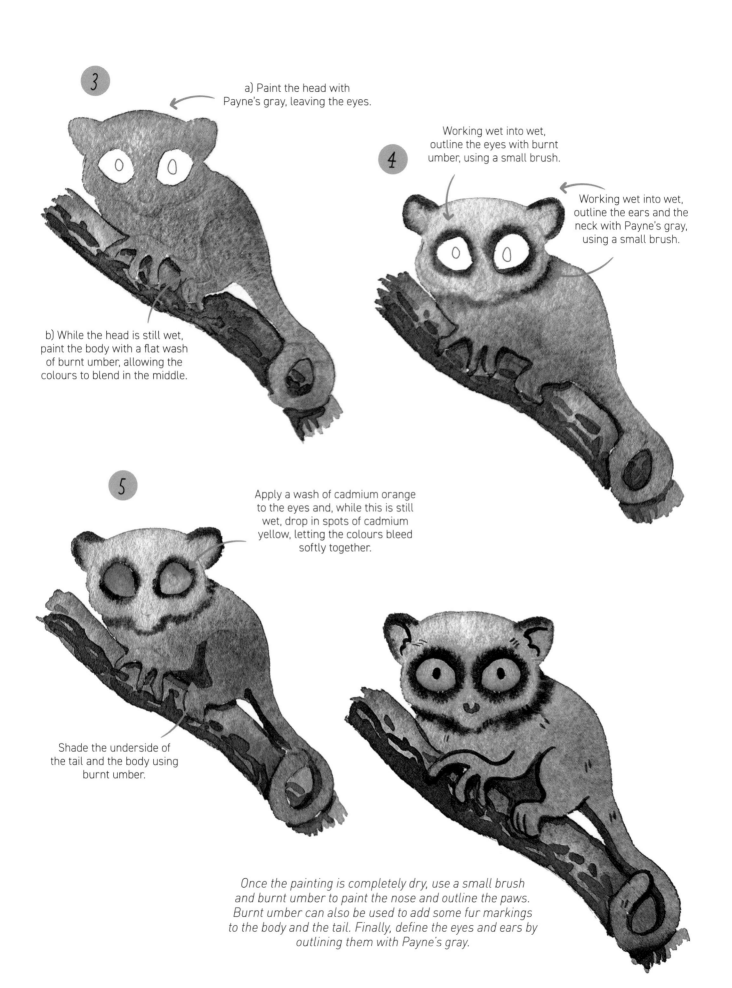

3

a) Paint the head with Payne's gray, leaving the eyes.

b) While the head is still wet, paint the body with a flat wash of burnt umber, allowing the colours to blend in the middle.

4

Working wet into wet, outline the eyes with burnt umber, using a small brush.

Working wet into wet, outline the ears and the neck with Payne's gray, using a small brush.

5

Apply a wash of cadmium orange to the eyes and, while this is still wet, drop in spots of cadmium yellow, letting the colours bleed softly together.

Shade the underside of the tail and the body using burnt umber.

Once the painting is completely dry, use a small brush and burnt umber to paint the nose and outline the paws. Burnt umber can also be used to add some fur markings to the body and the tail. Finally, define the eyes and ears by outlining them with Payne's gray.

Bluebird

Drawing and colours

Transfer the line drawing to your watercolour paper as described on page 5.

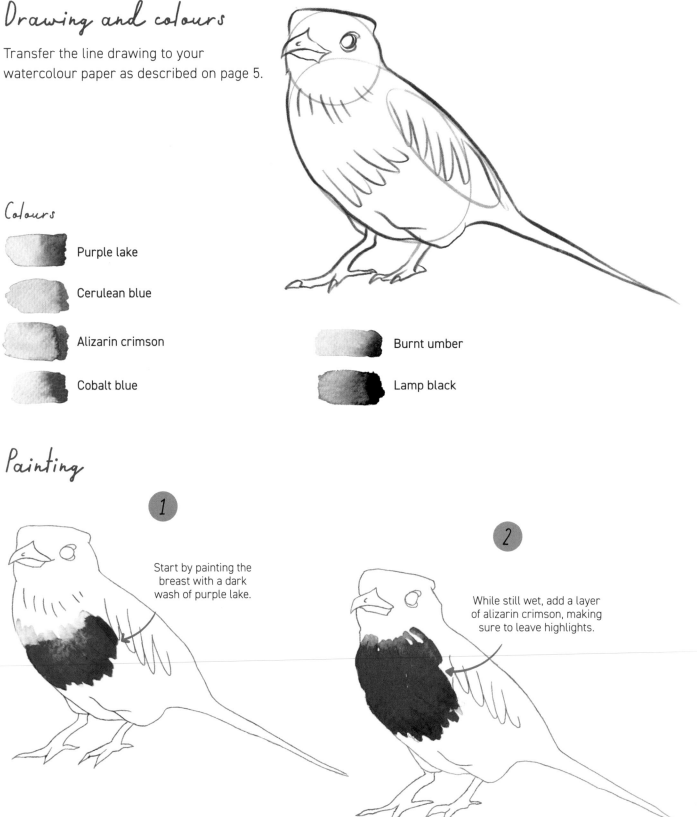

Colours

Purple lake

Cerulean blue

Alizarin crimson

Cobalt blue

Burnt umber

Lamp black

Painting

1

Start by painting the breast with a dark wash of purple lake.

2

While still wet, add a layer of alizarin crimson, making sure to leave highlights.

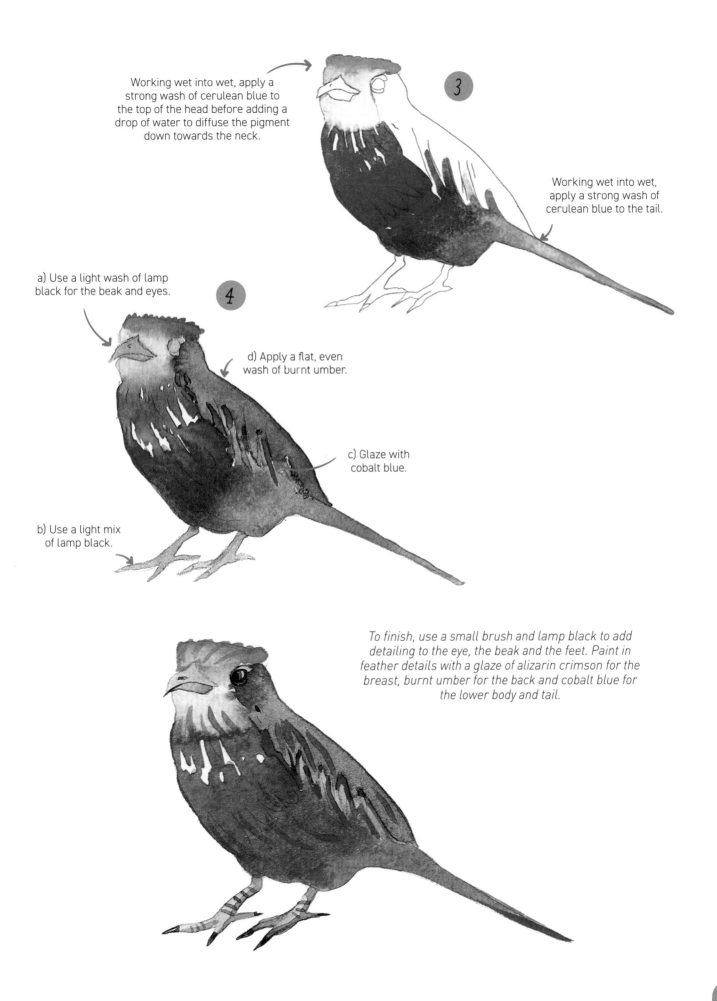

Working wet into wet, apply a strong wash of cerulean blue to the top of the head before adding a drop of water to diffuse the pigment down towards the neck.

3

Working wet into wet, apply a strong wash of cerulean blue to the tail.

a) Use a light wash of lamp black for the beak and eyes.

4

d) Apply a flat, even wash of burnt umber.

c) Glaze with cobalt blue.

b) Use a light mix of lamp black.

To finish, use a small brush and lamp black to add detailing to the eye, the beak and the feet. Paint in feather details with a glaze of alizarin crimson for the breast, burnt umber for the back and cobalt blue for the lower body and tail.

Butterfly

Drawing and colours

Transfer the line drawing to your watercolour paper as described on page 5. For this project you will need masking fluid.

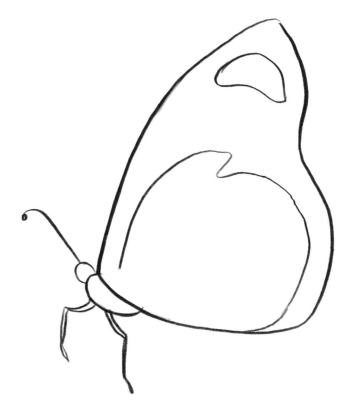

Colours

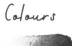 Ultramarine

 Dioxazine violet

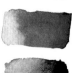 Lamp black

Painting

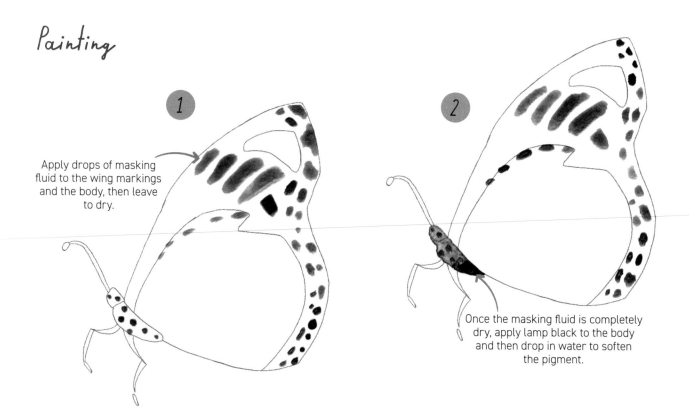

1 Apply drops of masking fluid to the wing markings and the body, then leave to dry.

2 Once the masking fluid is completely dry, apply lamp black to the body and then drop in water to soften the pigment.

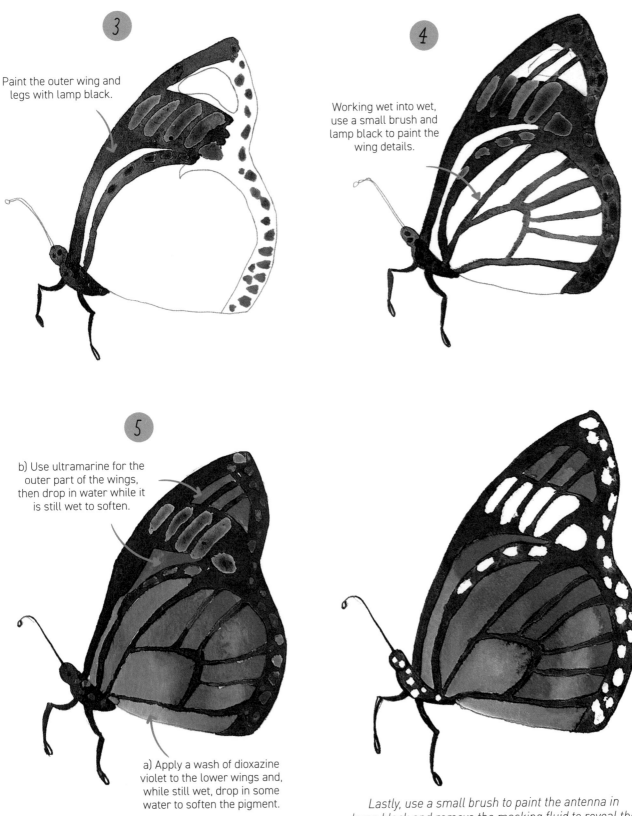

3

Paint the outer wing and legs with lamp black.

4

Working wet into wet, use a small brush and lamp black to paint the wing details.

5

b) Use ultramarine for the outer part of the wings, then drop in water while it is still wet to soften.

a) Apply a wash of dioxazine violet to the lower wings and, while still wet, drop in some water to soften the pigment.

Lastly, use a small brush to paint the antenna in lamp black and remove the masking fluid to reveal the final painting.

Owl

Drawing and colours

Transfer the line drawing to your watercolour paper as described on page 5.

Colours

Cadmium yellow pale

Yellow ochre

Burnt sienna

Raw umber

Payne's gray

Painting

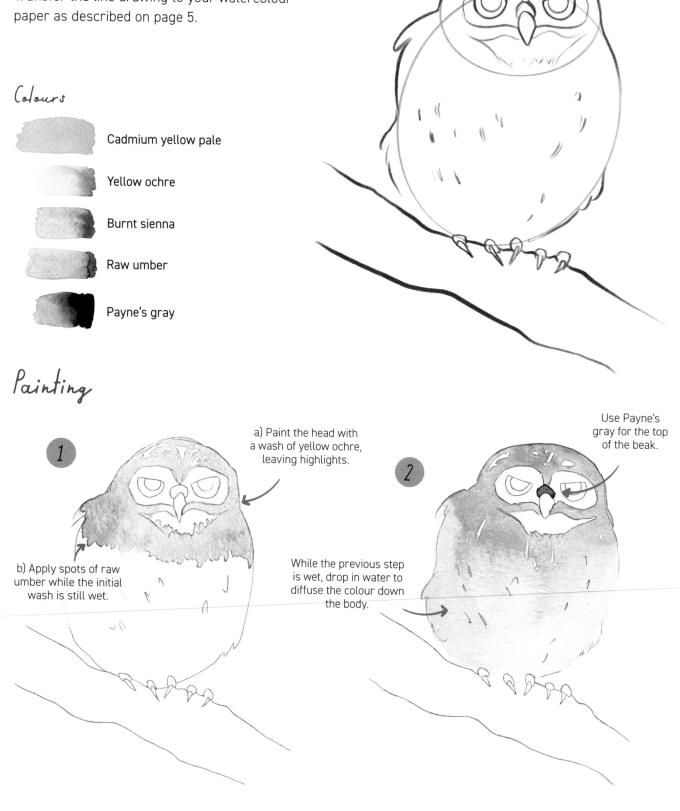

1

a) Paint the head with a wash of yellow ochre, leaving highlights.

b) Apply spots of raw umber while the initial wash is still wet.

2

Use Payne's gray for the top of the beak.

While the previous step is wet, drop in water to diffuse the colour down the body.

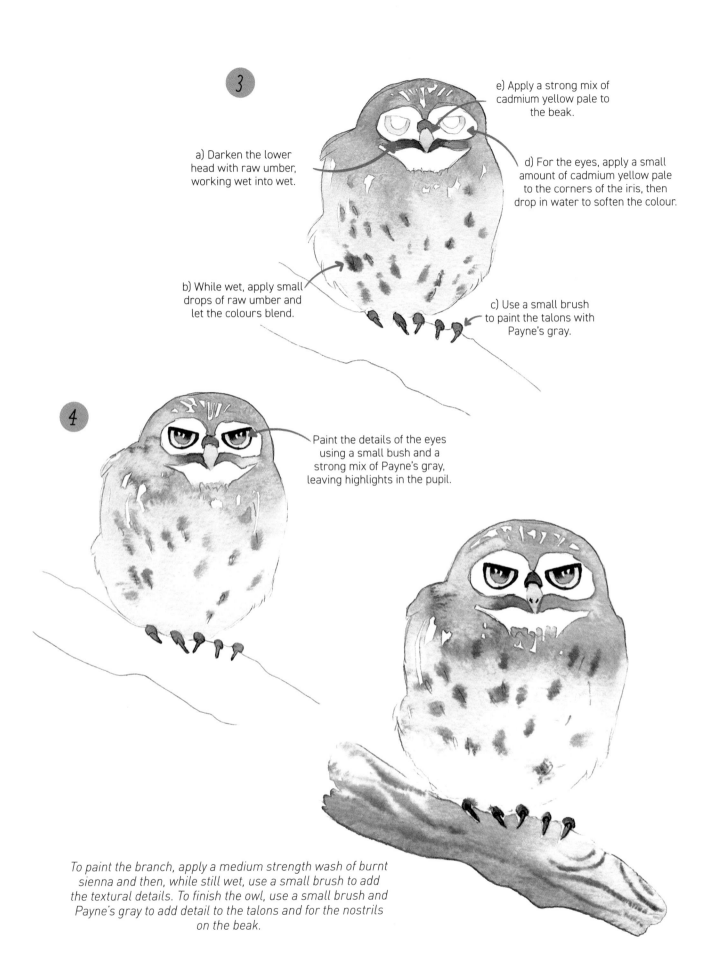

3

a) Darken the lower head with raw umber, working wet into wet.

b) While wet, apply small drops of raw umber and let the colours blend.

e) Apply a strong mix of cadmium yellow pale to the beak.

d) For the eyes, apply a small amount of cadmium yellow pale to the corners of the iris, then drop in water to soften the colour.

c) Use a small brush to paint the talons with Payne's gray.

4

Paint the details of the eyes using a small bush and a strong mix of Payne's gray, leaving highlights in the pupil.

To paint the branch, apply a medium strength wash of burnt sienna and then, while still wet, use a small brush to add the textural details. To finish the owl, use a small brush and Payne's gray to add detail to the talons and for the nostrils on the beak.

Ram

Drawing and colours

Transfer the line drawing to your watercolour paper as described on page 5.

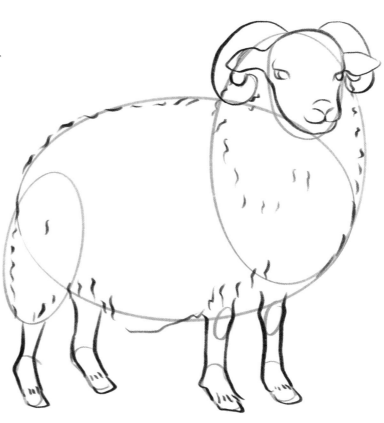

Colours

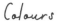 Payne's gray

 Burnt umber

 Raw umber

Painting

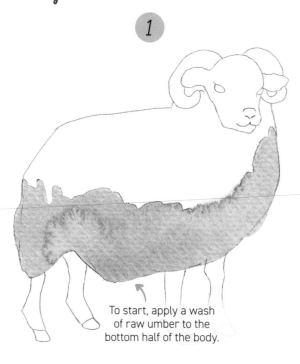

1

To start, apply a wash of raw umber to the bottom half of the body.

2

Add water to diffuse the colour upwards.

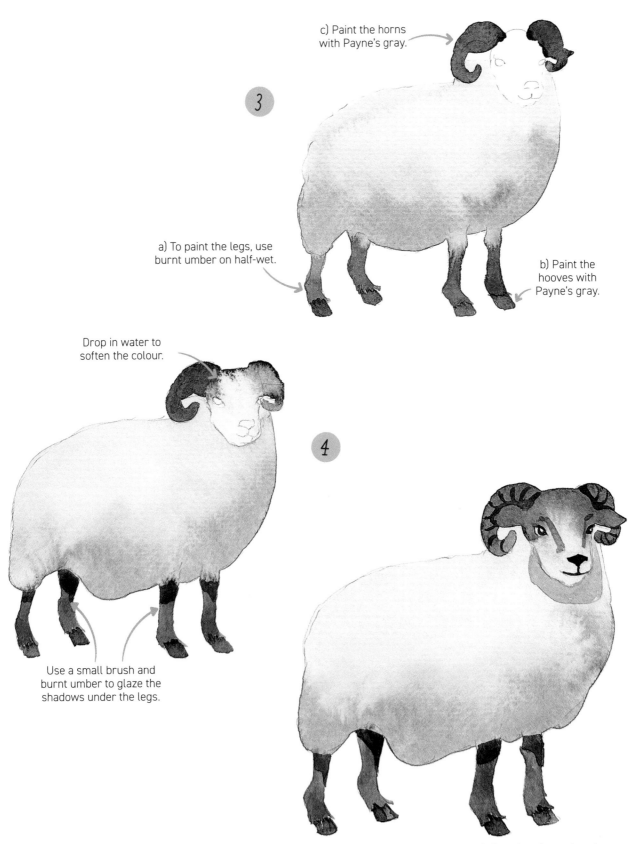

c) Paint the horns
with Payne's gray.

3

a) To paint the legs, use
burnt umber on half-wet.

b) Paint the
hooves with
Payne's gray.

Drop in water to
soften the colour.

4

Use a small brush and
burnt umber to glaze the
shadows under the legs.

*Glaze the face with raw umber to define the shape. Lastly,
use a small brush and Payne's gray to paint the final details
on the face.*

Mouse

Drawing and colours

Transfer the line drawing to your watercolour paper as described on page 5.

Colours

 Alizarin crimson

Cobalt blue

Payne's gray

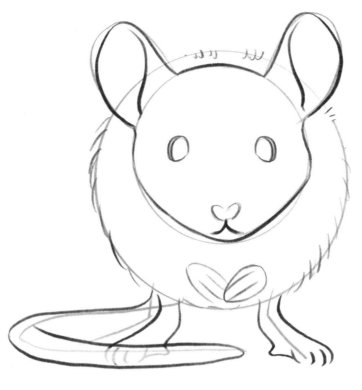

Painting

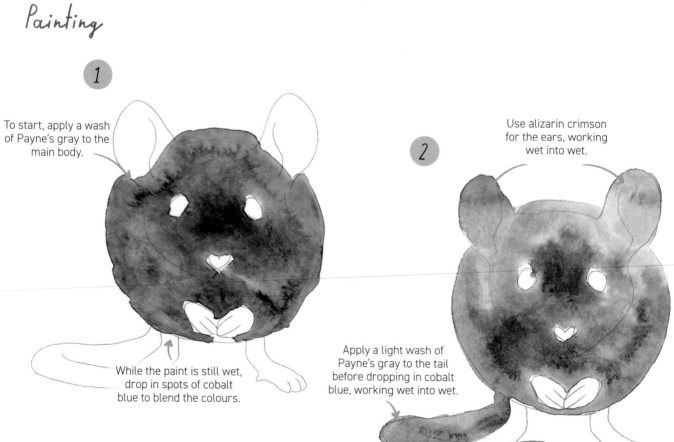

1

To start, apply a wash of Payne's gray to the main body.

While the paint is still wet, drop in spots of cobalt blue to blend the colours.

2

Use alizarin crimson for the ears, working wet into wet.

Apply a light wash of Payne's gray to the tail before dropping in cobalt blue, working wet into wet.

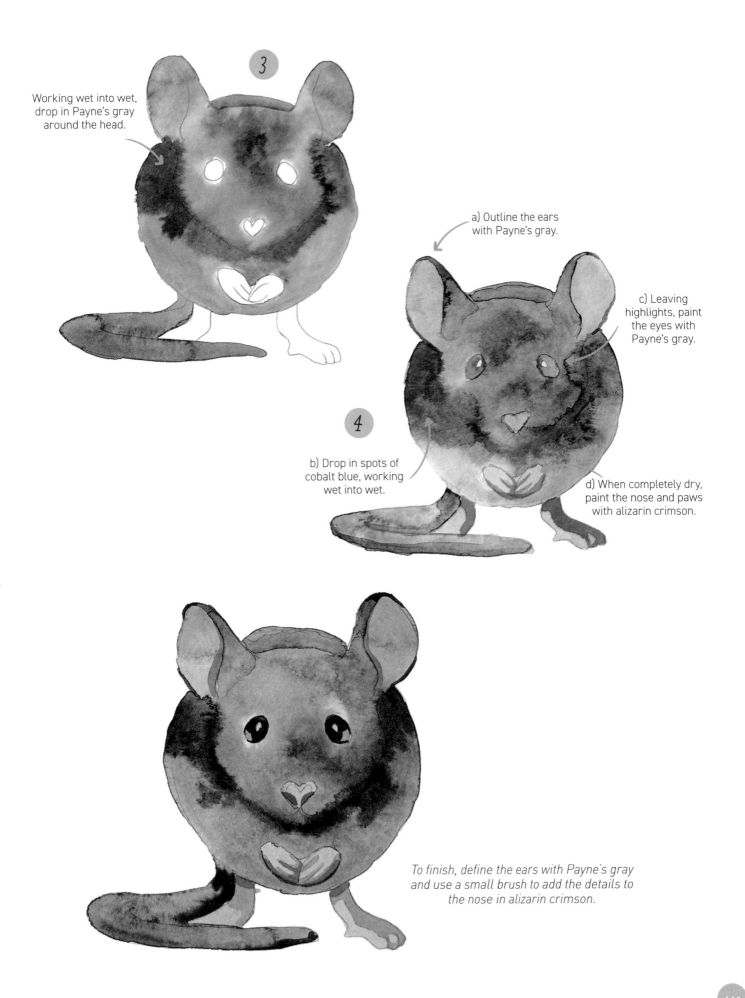

Working wet into wet, drop in Payne's gray around the head.

3

a) Outline the ears with Payne's gray.

c) Leaving highlights, paint the eyes with Payne's gray.

4

b) Drop in spots of cobalt blue, working wet into wet.

d) When completely dry, paint the nose and paws with alizarin crimson.

To finish, define the ears with Payne's gray and use a small brush to add the details to the nose in alizarin crimson.

Ostrich

Drawing and colours

Transfer the line drawing to your watercolour paper as described on page 5.

Colours

 Cadmium red pale

 Burnt umber

 Lamp black

 Raw umber

 Payne's gray

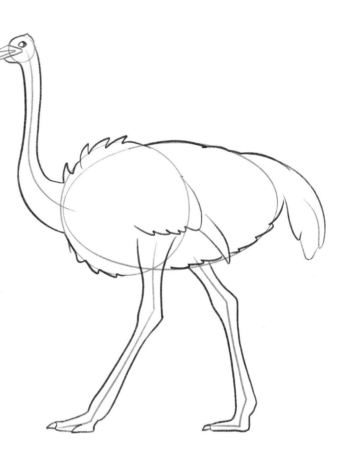

Painting

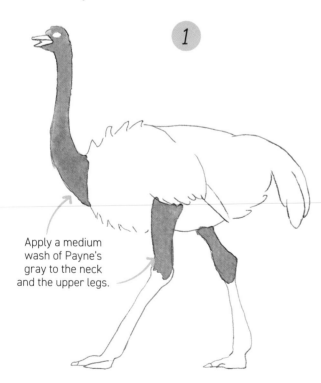

1

Apply a medium wash of Payne's gray to the neck and the upper legs.

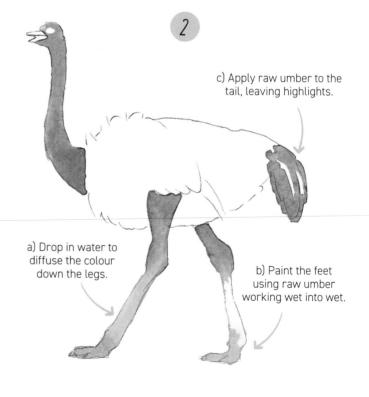

2

c) Apply raw umber to the tail, leaving highlights.

a) Drop in water to diffuse the colour down the legs.

b) Paint the feet using raw umber working wet into wet.

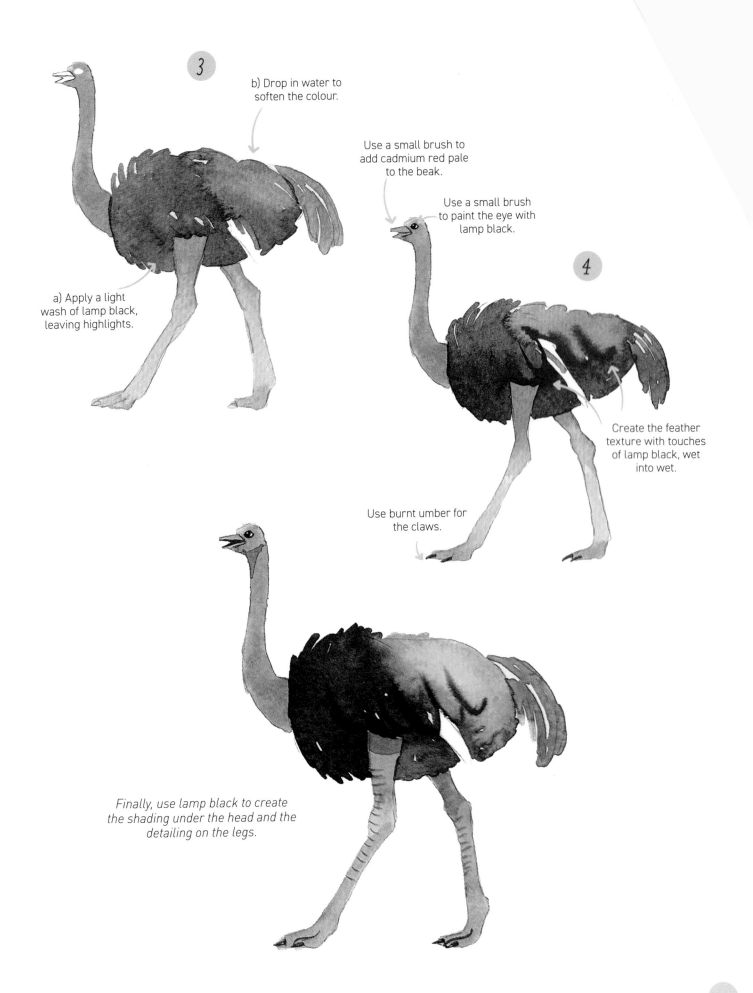

3

b) Drop in water to
soften the colour.

Use a small brush to
add cadmium red pale
to the beak.

Use a small brush
to paint the eye with
lamp black.

4

a) Apply a light
wash of lamp black,
leaving highlights.

Create the feather
texture with touches
of lamp black, wet
into wet.

Use burnt umber for
the claws.

*Finally, use lamp black to create
the shading under the head and the
detailing on the legs.*

PAINT 50 WATERCOLOUR ANIMALS

First published in 2024

Search Press Limited
Wellwood, North Farm Road,
Tunbridge Wells, Kent TN2 3DR

ISBN: 978-1-80092-128-3
ebook ISBN: 978-1-80093-118-3

You are invited to view the author's work at:

– her portfolio: behance.net/MarinaBakasova

– Marinabksv on www.artstation.com

– @marinabks on Instagram

Acknowledgments

In 2021 my family lost our amazing grandfather, so I devote this book to him.

Thanks from the bottom of my heart to my adorable family, especially to my biggest supporter – my younger sister, Victoria.

I am grateful to be a part of a society of illustrators and I thank the team at Search Press for the opportunity to write and illustrate my own book.

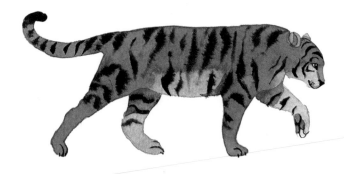

MIX
Paper | Supporting responsible forestry
FSC® C020056
FSC
www.fsc.org